COASTAL CASTLES *of* NORTHUMBERLAND

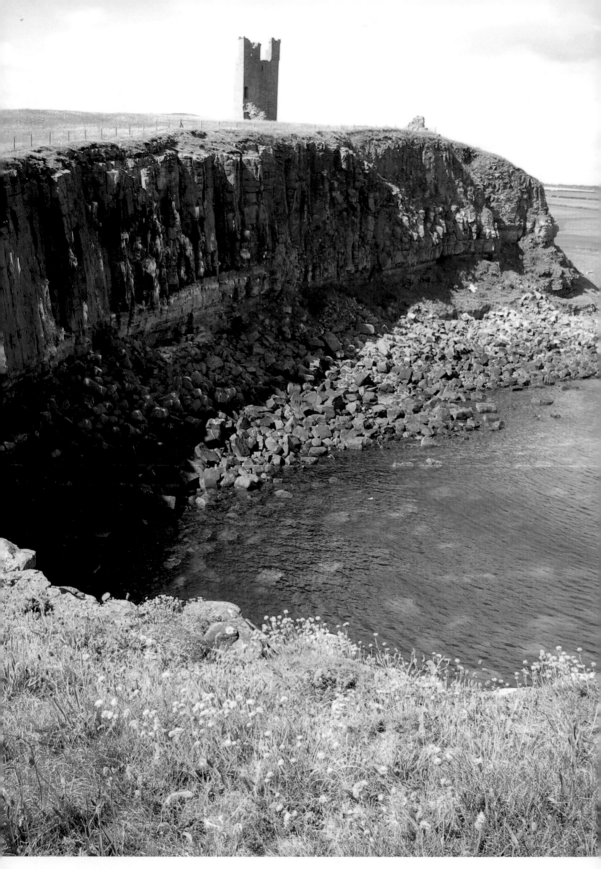

The Lilburn Tower on the top of the north cliff at Dunstanburgh Castle.

COASTAL CASTLES *of* NORTHUMBERLAND

STAN BECKENSALL

AMBERLEY

ACKNOWLEDGEMENTS

I am very grateful to Gordon Tinsley for his photographs taken from a helicopter, to Marion Clark for hers, and to Newcastle University. These are acknowledged in the text. Each castle has a guardianship, and these have produced some high-quality guide books to the sites that I have found useful. My thanks go also to my editor, Louis Archard, and everyone else at Amberley for their skilful production.

First published 2010

Amberley Publishing
Cirencester Road, Chalford,
Stroud, Gloucestershire, GL6 8PE

www.amberleybooks.com

British Library Cataloguing in Publication Data.
A catalogue record for this book is available from the British Library.

ISBN 978-1-4456-0196-0

Typesetting and Origination by Amberley Publishing.
Printed in Great Britain.

CONTENTS

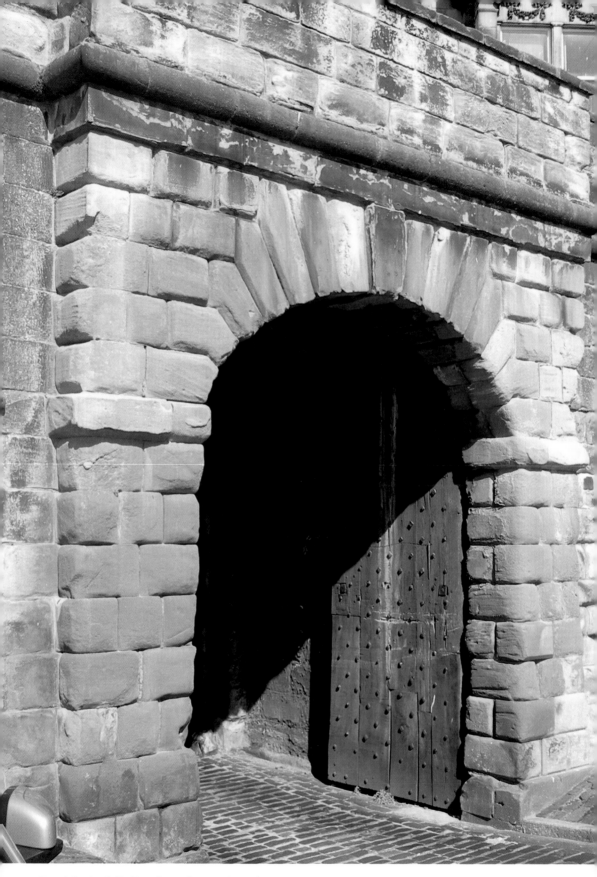

Berwick, the Sally Port from the west into the town.

AN INTRODUCTION

A constant factor in human history is the need to protect oneself. Another factor is the urge to attack someone else.

Until the Normans imposed their sophisticatedly-designed castles on Britain, the country had seen many structures that met either of these needs in a different way. Before the Romans brought their efficient war-machine across the Channel and based its troops in a variety of walled buildings, their prehistoric antecedents had done the same thing, but in a different way. The Roman army proved too much for the stone, earth, timber-walled and ditched enclosures that survive more or less in Iron Age regional capitals such as Maiden Castle and Danebury in the south, and in local hillforts such as Yeavering Bell in Northumberland, although this was a giant construction compared with the other scattered small enclosures that still survive widely.

It is simplistic to think of some of these early fortresses as simply defensive or as a base for aggression, for the 'hillfort' served other purposes such as a gathering place for farmers scattered widely over the land, a place where they established a regional identity and a claim to the land through their ancestors, who may have used the sites of the forts hundreds of years before their final appearance at the beginning of the Roman conquest.

The Romans gave to the world a different concept of defence and attack, principally the finely-honed tactics that chose pitched battles as their main strategy, based on absolute discipline and practice. All along Hadrian's Wall they built their stone forts to house infantry and cavalry, ready to sally forth in great numbers to confront a threat or as a stepping stone to further conquest. They linked such forts along the Wall into a chain of milecastles and turrets at regular intervals, fronted by a ditch and backed by a Vallum, and with a road network connecting them to supply bases, as well as each other. The locals would have found this unique and bewildering.

The downfall of Rome and the abandonment of the Wall frontier paved the way for another kind of fighting, based on the warlord and his band crossing the sea from northern Europe, at first to pillage, and gradually for settlement. Success in such a society was based on prowess in battle, and the rulers who emerged in such a way were often killed early in life. Armies ranged widely across Britain and it did seem to be all about the survival of the fittest. There were regional bases for these warriors, such as one that was established on the basalt outcrops of Bamburgh by Anglians, and these produced their own rival territories and kings. By the time of the Norman invasion, conflicts between rivals continued to split the land, and had Harold not been forced to beat off one of his rivals not long before the battle with William the Conqueror, and had his men not fallen for a Norman trick, the story might have been quite different. As it was, the Norman French stamped their claim upon the land through conquest by building castles that showed who the new bosses were. The castle was the outward and visible sign of their domination, adopted by every Norman who had received his reward for joining William in his claim to England. With

the castle came a network of feudal relationships that characterised the hierarchy, with the local peasants at the bottom of the pile.

Northumberland has a large share of such castles, but there is a difference from those found further south. For long after many regional lords had begun to seek better accommodation in more peaceful times than a large draughty castle, the northern regions continued to be turbulent, particularly because of enduring bad relations with Scotland and because of the activities of local Border 'surnames' that went their own way with their own rules. Not only did some major castles continue to be re-fortified and used, but also a rash of smaller defended towers and bastles spread throughout the region in a kind of local tribalism.

Some of the most spectacular castles occupy the coastal plain. Geologically this provided a stretch of fertile, low-lying land through which the main rivers empty from the west into the North Sea. The county is one of contrasts: the volcanic Cheviot Hills produce a different way of life for their inhabitants from those living on the coast, and so do the scarplands and major river valleys. The coast was vital for communication, not only by sea but also by land, and it was fertile.

Early Norman castles started in motte and bailey form: a large mound was dug from a circular ditch around it, and capped with a stockade and wooden tower. The enclosing fence could include an annexe – a bailey, where more space could be used for housing, barracks, stables and workshops. A fine example of such a plan can be seen at the Moot Hills, Elsdon, where the castle was not further developed in stone. It was stone that became the preferred material for castle building. Although the keep built on top of the motte became the central feature, housing the lord and his retainers, the surrounding walls became the first line of defence, with the addition of towers (square and round according to experience of their use) and a defended gateway.

As people in this region were not constantly at war, as wealth grew from exploiting the rich farmland and woodland, the lords needed to spend more of their wealth on their power-base to defend it and to impress others. Changes in castle building came from many sources, and we see circular keeps and circular towers that were more resistant to being undermined by sappers, with gun ports and platforms, for example. There were other innovations to make the castle more congenial to live in and more impressive to show off, such as the addition of attractive windows and interior decoration and furniture. The more peaceful the times, the more emphasis was placed on such niceties.

The two large castles on the coastal plain that have survived most successfully are those at Alnwick and Bamburgh. The latter was largely rebuilt by Lord Armstrong of Cragside, who was a brilliant engineer and innovator and used some of his fortune in buildings. Unlike the nobility who built the castles originally, his wealth came not from the traditional holding of land but from science and industry. Alnwick is still the seat of the Duke of Northumberland, a wealthy landowner in whose name the castle goes back for centuries. It has survived because it continues to be lived in, and flourishes because the use of its grounds has been expanded. All this is different from the castle at Berwick, which was partly demolished to make way for a railway station, or the abandoned, picturesque Dunstanburgh. Warkworth is partly in ruins. Holy Island castle survives because of its late building and use. Castles were abandoned when they became redundant: gunpowder put paid to many of them, but once there was peace the owners wanted the good life away from the cold and draughts – another part of the story.

This brief introduction sets the themes of this book; it is a visual history of these coastal castles, for history can be read not only in documents but also in what is left on the ground.

THE ESSENCE OF
THESE CASTLES

*Each castle is briefly described below, and the section
that follows looks at each one in detail.*

BERWICK

Although the oldest part of Berwick's defences is a Norman castle, what is so strikingly visible is the extent of the Elizabethan defences that enclose the town.

The settlement of Berwick in Anglian times probably grew up as a farm that specialised in growing barley, for that is what the name *bere wic* means. It is one of many along the coast that has the same kind of reference to specialisation, such as goose farm at Goswick or cheese farm at Cheswick. It was, however, to become an important flash-point in Anglo-Scottish rivalry, changing hands and suffering slaughter and destruction from both sides as many as fourteen times in 300 years.

The remains of the medieval castle, compared with the walled town that we see today, are sparse. The castle lay outside the medieval town wall, separated by a ditch, with an entrance that led in from the town, but the railway has destroyed most of those remains, driving right through it.

So when did the castle begin? Probably it began in 1160, followed by a makeover when Edward I ('The Hammer of the Scots' and a prolific castle-builder) captured it in 1296. His castle had curtain walls with towers and turrets, with buildings set inside the walls. The only remnants are in Castle Vale Park, where there is a south-east angle tower with some curtain wall. This Constable Tower survives with its lower courses possibly of the same date, rebuilt on that foundation with a polygonal construction of good sandstone ashlar facing. There is also a garderobe chute. Another survival is the north-west wall of the castle, seen from the station platform, at the north end of which is a tower, and at its south end a semi-circular 1540 gun turret which overlooks the river. Finally there is a wall running west down the hill to the river to cut off any invaders that might try to reach the town along the river bank. This was built in 1297, and at its foot the Water Tower was added in 1540.

The castle was connected to the town, which was enclosed in walls that Edward I began to build to replace in stone the earlier, more primitive, palisade. The Scots overran these low walls, and in 1318 built their own higher.

The northern part of the town wall was later abandoned and decayed, but some can still be traced, built into the Elizabethan defensive ramparts. An important survival of the medieval wall is the Bell Tower at the north-east angle, later rebuilt.

There were efforts to build strong defences around the town again, but the final push came in 1558 to counter threats from Scotland; the latest Italian technology was harnessed in the design, so that guns could rake the cleared land around with devastating

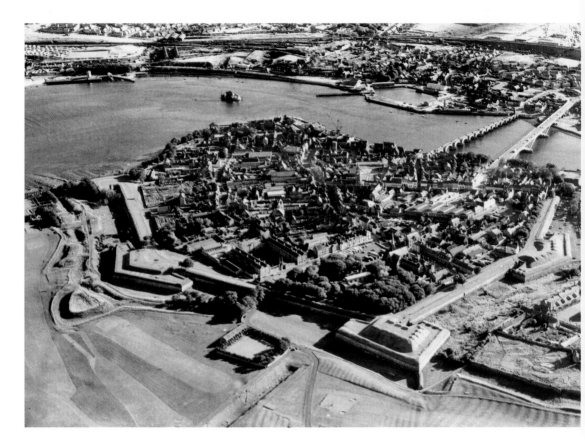

cross-fire from protected batteries. The predominant element in this was the building of bastions which could not only fire across the approach from the north, but also catch the attackers in cross-fire close to the walls. This work took place from 1558-69 but was not finished, and today we see only the north and east sides complete, with the south and west continuing to use the medieval wall. After the union of the Crowns in 1603, Berwick continued in use as a military base. The earth embankments that rise high above the bastions were added from 1639-53. In the eighteenth century the building of the Barracks is a visible sign of its continued use as military base.

The pictures offered give glimpses of some of the early features, and others reflect on the changing nature of warfare that made the defences of Berwick so innovative.

HOLY ISLAND CASTLE

What is so dramatic about parts of the coast is the natural intrusion of volcanic basalt (or dolerite). Known locally as whinstone, favoured by gorse, it has greatly influenced the choice of sites where people built castles, as we see at Holy Island, Bamburgh and Dunstanburgh. It also directed Hadrian to use its topography in the central section of the Roman Wall. These castles look out from their natural heights over the North Sea to islands that are made of the same stuff.

Holy Island was originally called Lindisfarne, the name possibly derived from its settlement by travellers from Lindis in Lincolnshire, and is one of the world's most famous islands. It was the centre of early Christian missionary activity in a largely pagan world from its Celtic monastic base, producing scholars of international reputation

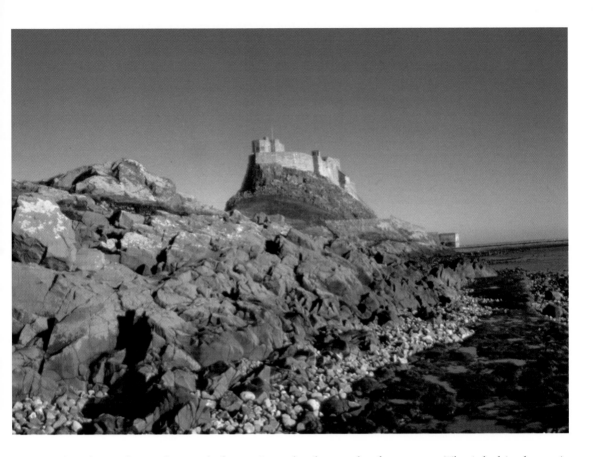

and such works as the Lindisfarne Gospels, the work of one man. The inhabited part is around the small harbour where the monastery used to be, replaced in Norman times by a church, priory and its attendant buildings. The island is tidal, and crossing can be perilous even today when feckless people, ignoring warnings, drive over the causeway and get stuck.

The monastic settlement was destroyed by Vikings, when it seemed that people had been abandoned by God and all the saints. In turn the Norman priory was dissolved under Henry VIII, leaving ruins and an intact parish church of great antiquity.

The castle stands apart from this settlement, using the height of the whinstone pillars to lift it above the harbour and sea, where it stands guard. The whinstone outcrop emerges on the other side of the harbour in a line called the Heugh (cliff), forming another lookout place. There was a small fort built on the Heugh in the seventeenth century, with scanty remains now overlooking the harbour.

Whatever may have been there before, the castle that we see today was built by the Crown in 1549-53 to defend the coast with guns on two levels. It was garrisoned until 1819, used as a coastguard station, and in 1902, although decayed, was bought by the owner of *Country Life*, Edward Hudson. The outer walls were in good order, but the interior was not, so to make it habitable and attractive he got Sir Edward Lutyens to do the job. Luckily he was concerned with retaining the ancient integrity of the building, and left what was old and impressive without changing its form. To his credit this worked, and his renovation is basically what visitors to this National Trust property see. The Trust continues to respect this integrity, for recently they insisted on re-facing one external wall with traditional materials. Outside there is a Gertrude Jekyll walled garden that looks towards this wall, giving one of many splendid views of the castle.

The site is approached by a ramp from the harbour which overlooks the remaining wooden piers of a jetty used for importing coal for cathedral-like lime kilns and the export of lime. The castle mound is shared by these kilns and the waggonway that brought the coal and lime to the tops of the kilns to be poured in. Castle, limekilns, garden and line of an old narrow-gauge railway make this a very interesting group.

BAMBURGH CASTLE

Bamburgh Castle is one of the most impressive castles in Britain, especially as it is borne aloft on whinstone crags above a sweep of lovely sand. Viewed from Holy Island it stands out to the south, and the inland approach from the west is particularly arresting. It is what everyone imagines and wants a castle to be, yet much of it is a modern restoration, carried out with skill and sensitivity.

We have documentary evidence that the site was a vitally important base for Anglian warlords who came to dominate this part of northern England, and to extend their frontiers well beyond it. In 980 it was *Bebbanburgh*, named after Bebba, wife of King Aethelfrith of Bernicia. Before this it is not surprising to find that it had a prehistoric use.

Rising above the beach to a height of forty-six metres is an outcrop of basalt that extends into a long ridge, enclosed by a wall that contains several acres. The basalt grows from sedimentary rocks, with a clear division between the two, and the castle is built of the most easily-workable, softer sandstone that appears to change colour in the setting sun.

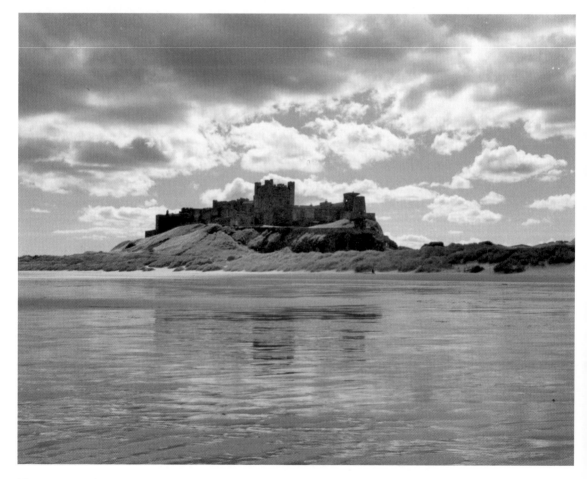

In a ward to the west, excavations have revealed occupation from the Iron Age, but later castle-building has covered much of the earlier history. Roughly at the south centre of this elongated enclosure a Norman keep, its entrance on the ground floor, rises above the restored massive curtain wall. Three wards divide the rest of the space, ending at the east at a partly Norman gatehouse that gives an entrance to the castle through an inner gateway.

Because the castle fell into ruin, and has been largely rebuilt in the eighteenth and nineteenth centuries, it is not easy to see how much medieval work there is left. It was bought by Lord Crewe, Bishop of Durham, in 1704, whose death-wish was that his estates should go to charity, and the Crewe Trust began the restoration in 1757. Thus the keep was restored, fit for hospitality, and new apartments were built along the south wall. The curtain wall was rebuilt and a working windmill erected at the east end. The castle became a charity institution, with school, hospital, library, granary and accommodation for shipwrecked sailors. It was bought by Lord Armstrong, and changes were made from 1894-1904, remodelling much of what had already been done. His main changes were the building of state rooms and apartments along the south wall of the Inner Ward. The bay windows in particular give a striking view from the south. A ruined twelfth-century chapel, of the same time as the keep, has been retained.

DUNSTANBURGH CASTLE

Dunstanburgh takes a similar advantage to Bamburgh from the whinstone, which forms a precipitous ready-made platform and ditch to protect it. It takes its name from nearby Dunstan, which means a stone hill; the 'burgh' means a fortification. Again, it is situated on one England's finest coastlines, with the lovely coloured sand, eroded rounded boulders, sedimentary rocks running out to sea with the inclusion of an anticline, and the extraordinary shapes of the basalt columns of Embleton Bay giving it a superb setting.

Like Bamburgh, the main castle-building material is sandstone, in this case so formed that it has weathered into something resembling Emmental cheese in parts. Instead of having a fringe of sand dunes, though, the sea here reaches right to the base of steep cliffs which are white with the droppings of thousands of nesting birds, which perch perilously on tiny ledges. They wheel over the sea, plunge in, and bring back food for their young. The contrast to all this hectic activity is the calm appearance of the castle, which from a distance seems to raise fingers from buried hands to the sky. It is still, abandoned and austere. Close to the silted former harbour there is rig-and-furrow ploughing and enclosures on the sheltered side of the promontory. The massive drum towers of the gatehouse face the easiest approach from Craster to the south.

As at Bamburgh, there are signs that the promontory was once an Iron Age enclosure, perhaps taken over by the Romans and Anglian settlers, but again the castle building has covered the ground where firm evidence might have lain. It has a big advantage over other coastal castles in that it was abandoned before it had been extensively modified, so what we see is largely what was there in the fourteenth century. The choice of such a site meant that it was already largely fortified naturally; a curtain wall runs round the promontory, except at the north's sheer drop. Buildings are concentrated on the approachable south side, the flat-backed drum towers serving as the keep, and the other towers are arranged seawards, with the Constable's Tower housing the man in charge. The gateway was modified to allow a passage to lead around the drum towers on the west and enter the castle grounds through a barbican in a change brought about by one of its famous owners, the Lancastrian John of Gaunt.

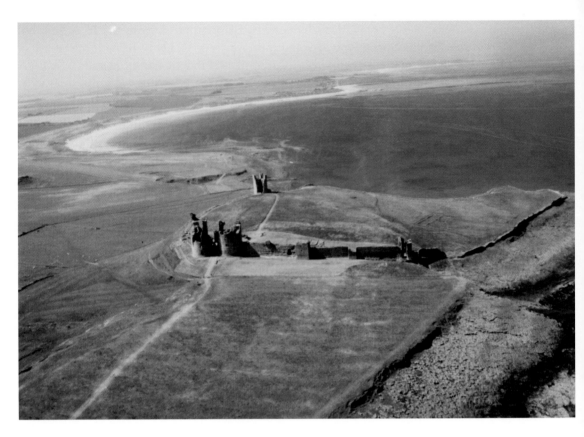

So, all the main buildings were concentrated to the south, which leaves a great area with apparently little in it except the visible foundations of a rectangular building. This area, however, could have housed troops and provided security for local people and livestock when necessary. In some ways, the castle site was rather remote from activity in the county compared with other castles – an isolation that today makes it particularly attractive.

ALNWICK

There has been so much activity at Alnwick Castle in the past fifty years, with film companies in particular raising awareness of it, that it has become a major tourist site. It is unique among the castles on the coastal plain in that its owners still live there for much of the time, and that it is still the centre of large working estates. Originally its name meant a farm on the River Aln.

It is not, like the others, on the coast itself, but its position on the River Aln, a major routeway to Scotland that follows the coast, gave it a special strategic importance. The site is well-chosen, placed above the River Aln, later overlooking the Lion Bridge and a Capability Brown landscape. The walled town of Alnwick is built up to it on the other side for protection. Although much of what we see is restored, the original plan of keep and two baileys (or wards) surrounded by a curtain wall and towers, pierced by one of the finest barbican gateways in the country, remains. It has been preserved by the decision of the Earls and Dukes of Northumberland to use it and live in it. There was a particularly intensive development in the nineteenth century, both internal and external, that makes it so poignant. The work has by no means stopped, and the Alnwick Gardens are the result of the energetic outpouring of the current Duchess, Jane, who is determined to continue its development as a

contemporary site rather than attempting to copy what has gone before. It is also clear from all these developments that tourism will bring big money into the area.

Part of the castle has been used since the end of the Second World War for teacher training – a role that ensured the buildings would be used and financed. When Alnwick College of Education was closed in 1977, students from St Cloud University were already coming in from the USA for part of their study courses. The wider public will have seen its role in the introduction to the Black Adder series, and in the Harry Potter films, to name but two.

The town and castle affect each other; although tourism has increased, this brings inevitable problems with parking and the need to preserve the very things of the past that attract people to it.

The pictures that follow will concentrate on the external features of the castle, which give the best view of its age and development.

WARKWORTH CASTLE

Unlike Alnwick, which is still in private hands, Warkworth castle is administered by English Heritage. It is closer to the coast than Alnwick, built on a promontory in a bend of the River Coquet, which includes both castle and village. Its name in 1040 was *Werceworth*, like Bamburgh named after a woman, this time Werce.

Once the river reached the sea here, but a change in direction made Amble the harbour. Although partly ruinous, the castle is a splendid building, especially its keep. I taught at Alnwick castle for eleven years, but my main extended contact with Warkworth was during preparations for the 1977 Pageant, which revived a pre-war tradition. It affects the way I view these castles, quite differently perhaps from that of a casual visitor.

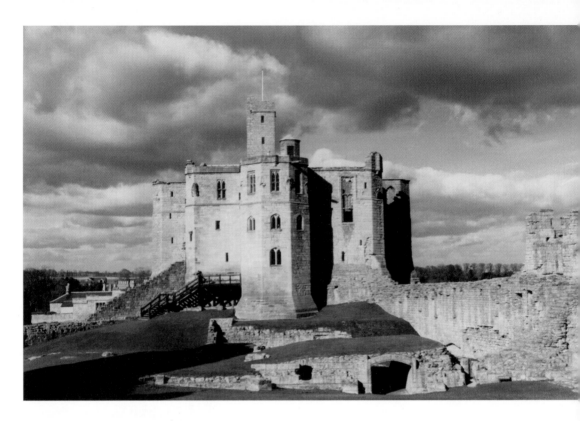

The high mound which dominates the village from the south was artificially built using material from the ditch that surrounds it, forming the base of a keep. The curtain walls and towers further enclose the area naturally created by the loop of the river, and a ditch and gateway cut off the castle from the southern approach. Outside this enclosure, to the north, the village lies on a gentle slope towards the river, its boundaries again defined by the course of that river, and its entrance over a guarded medieval bridge. Its Norman church dates from the same period as the first castle keep, and the long thin plots of land ('burgages' or 'scribes') that have houses on either side of the main street with gardens attached, were all deliberately planned in medieval times and mostly visible today.

The castle keep, the final development in the building, replaced earlier structures, taking on the quality of a residence that was both more comfortable and more impressive. Within the enclosure walls are various buildings of different periods and survivals, including the crypt and foundations of an unfinished church. The pictures that follow show what is to be seen today, the development of the castle building, and one dramatic use of the site in recent times.

BERWICK

A. MEDIEVAL BERWICK

The oldest fortification in Berwick is the castle, though there is little left of it. Norman in origin and design, it lay outside the town walls and was frequently attacked, but it was the building of the railway that finally destroyed most of it. To the east the medieval walls that were linked to the castle partly survive, reach a south-east corner tower, then run south, largely keeping to the coastal side of the Elizabethan defences. As the sixteenth-century building was not completed on its original plan, the line of the medieval wall was followed around the river bank, back to the north-west.

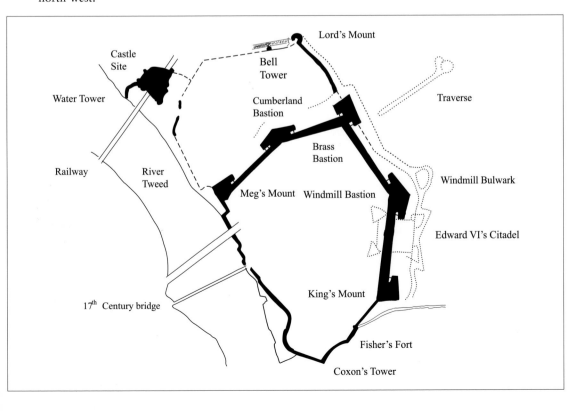

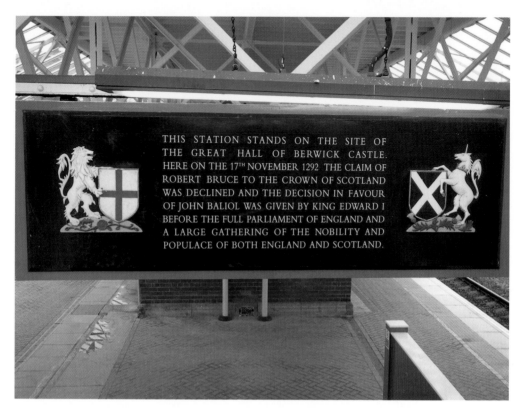

THIS STATION STANDS ON THE SITE OF THE GREAT HALL OF BERWICK CASTLE. HERE ON THE 17TH NOVEMBER 1292 THE CLAIM OF ROBERT BRUCE TO THE CROWN OF SCOTLAND WAS DECLINED AND THE DECISION IN FAVOUR OF JOHN BALIOL WAS GIVEN BY KING EDWARD I BEFORE THE FULL PARLIAMENT OF ENGLAND AND A LARGE GATHERING OF THE NOBILITY AND POPULACE OF BOTH ENGLAND AND SCOTLAND.

1a. The railway station notice briefly reminds visitors that the castle was destroyed by the building of the railway in the nineteenth century.

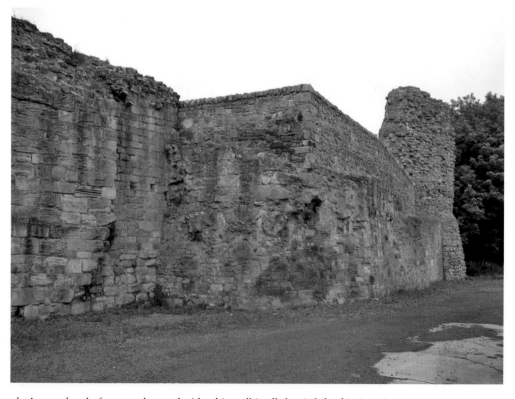

1b. Across the platform on the north side, this wall is all that is left of its interior.

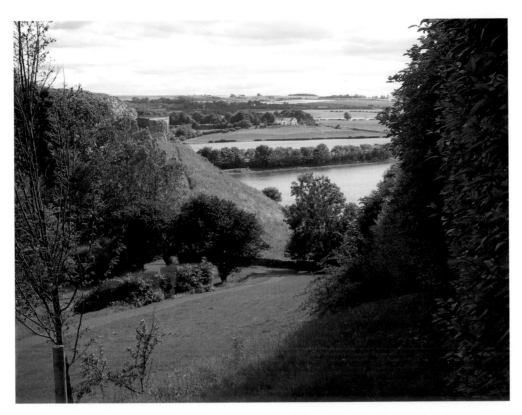

1c. The castle mound and ditch are still strongly visible on the north side, outside the station. Here we see the huge mound and ditch with the River Tweed to the west, as it nears the sea.

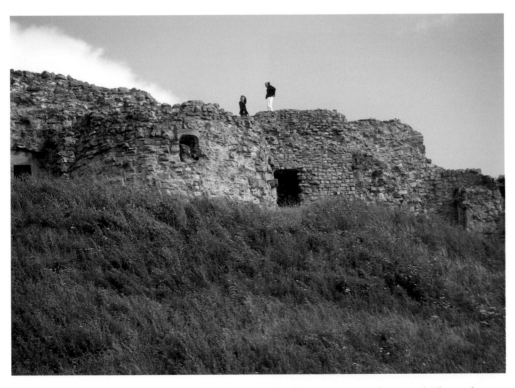

1d. The castle wall, which includes a rounded gun tower of *c*.1540, crowns the mound. The castle moat leads north to high ground, now partly built on.

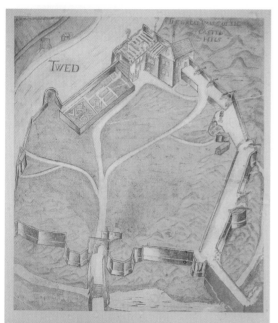

This is a bird's-eye view of Berwick Castle in 1789. The White Wall is hidden behind the buildings at the top. The castle was largely demolished by 1850, for the building of Berwick railway station and the Royal Border Bridge. Bodleian Library, University of Oxford (Gough Gen Top. 34, Vol 3, p.256)

1e. Berwick is admirable, provided with high-quality notice boards that explain its history. One of the most useful is this painting of the castle before its construction, from the Bodleian Library.

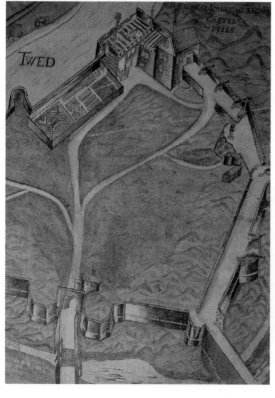

1f. The castle was divided from the town walls by a moat and drawbridge.

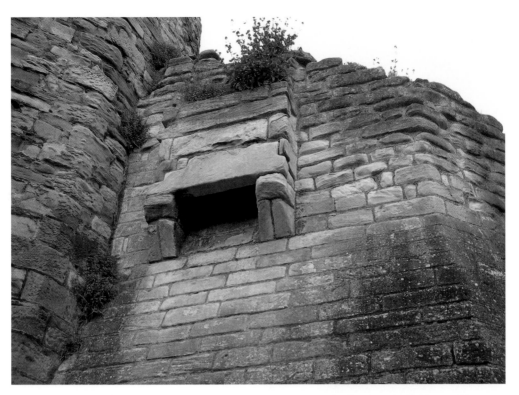

1g. The other surviving fragment of the castle is at the end of a lane from the railway station to the south-west, where there is the base of the Constable's Tower with the remains of a lavatory chute.

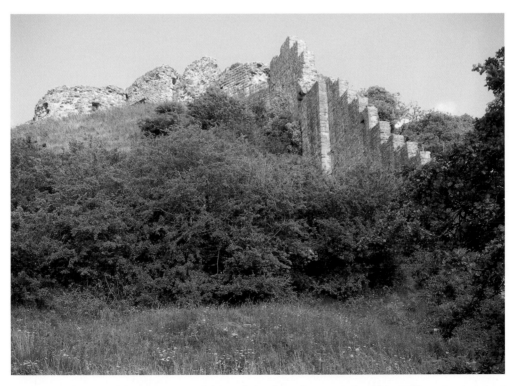

2a. A strong feature of the importance of the castle is what is known as the White Walls – a battlemented wall that runs from the castle corner down to the River Tweed to defend the river approach to castle and town. It probably dates from 1297-98.

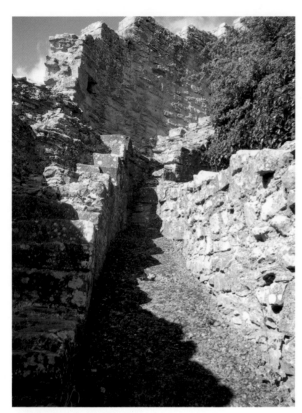

Left: 2b. The wall, with its 'Breakneck Steps', ends at the river, where a gun tower known as the Water Tower was built in the first half of the sixteenth century, at the same time as Lord's Mount (see below) and at the same time as the gun tower built on the north-west angle of the castle. It is possible that other additions and strengthening were made by Henry VIII to keep up with contemporary methods of siege warfare.

Below: 2c. The fort is seen in relationship to the river and the rail bridge.

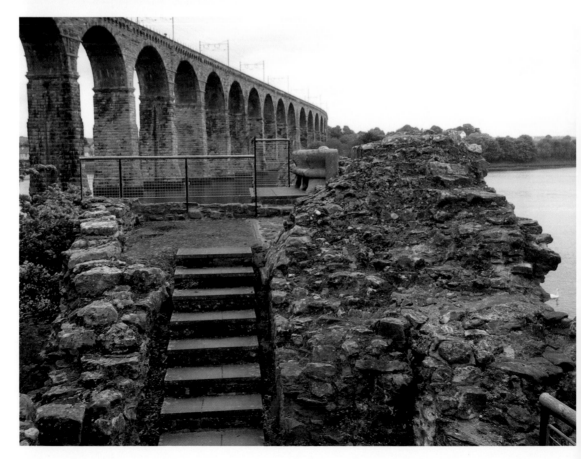

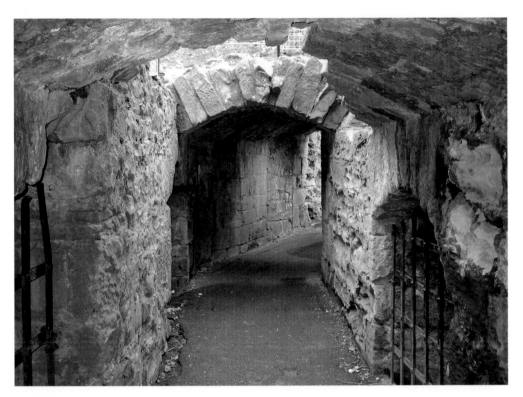

2d. Tunnels under the tower survive well.

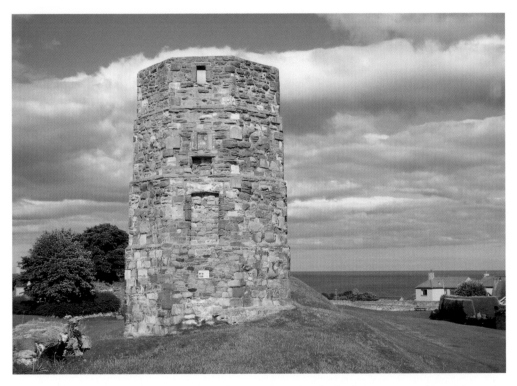

3a. Roughly east of the station/castle along the line of Northumberland Avenue are substantial remains of grassed medieval walls and ditches. Further north of this are two other ditches known as *Spades Mire*, about which little is known. What can be seen today is the Bell Tower, which stands out on a grass-covered wall above ditches.

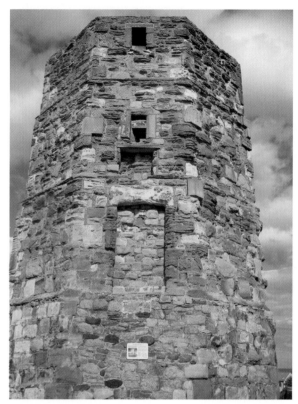

Left: 3b. The Bell Tower in sunlight is a colourful building, perched on the earth-covered mound of the rampart, through which some stone walling appears. It is octagonal, four storeys high, and the lower part is medieval. The rest was rebuilt in Tudor times. There are doors which gave access to the parapet walls, indicating the height of that wall.

Below: 4a. The medieval town wall turns at the ruins of a tower called Lord's Mount, built in 1539-42 to strengthen the defences. It lies on the north-east angle of the wall, seen here from the west to the sea.

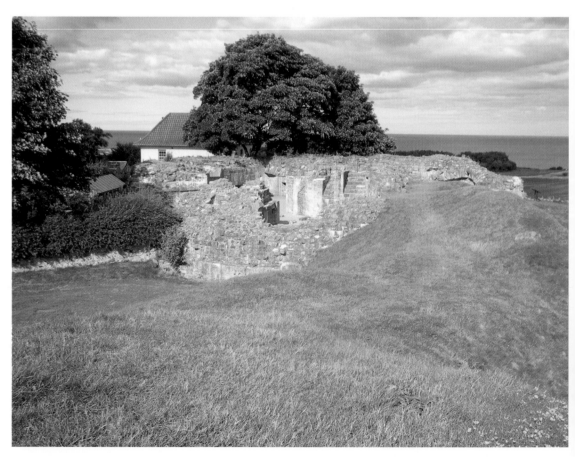

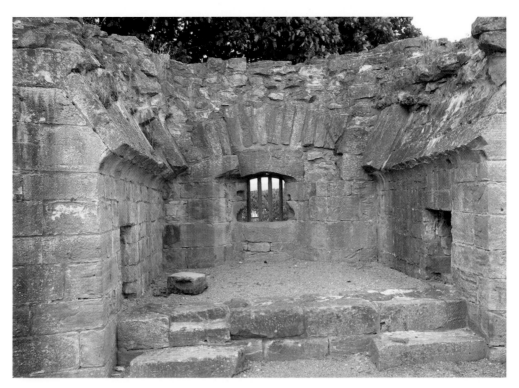

4b. Lord's Mount's upper floor and a parapet were demolished because they overlooked the Elizabethan defences, but what is left is an impressive gun-tower with very thick walls and six openings for artillery. One is pictured here.

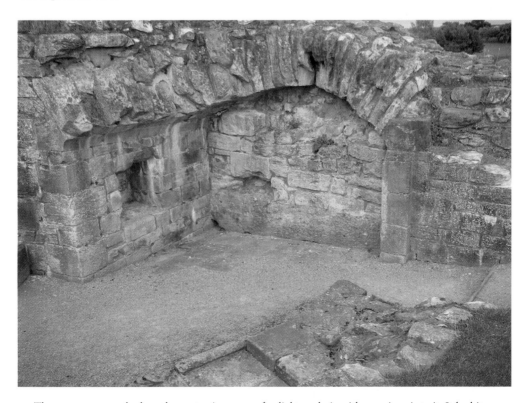

4c. The tower was vaulted; at the centre is a space for light and air with openings into it. It had its own kitchen, with a wide fireplace and oven.

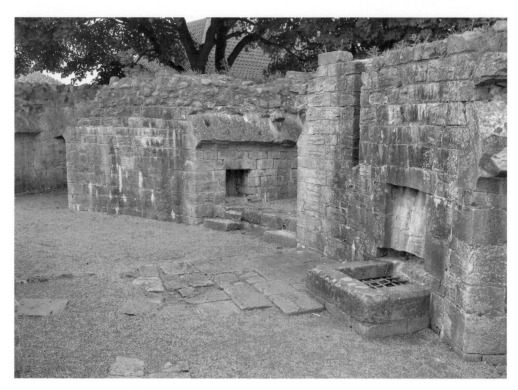

4d. Wells and raising mechanisms were installed.

4e. The building of the Elizabethan defences made this tower redundant, but the wall and ditch that run south from it continue to a point where they meet the Elizabethan wall at the Brass Bastion, seen at the top right behind the houses.

4f. Seaward (left), there is a large expanse of land that was cultivated with wide rig-and-furrow ploughing, now seen as a kind of switchback on the golf course. The Brass Bastion is on the right, and on the horizon Holy Island and the Farne Islands can be seen.

B. ELIZABETHAN DEFENCES

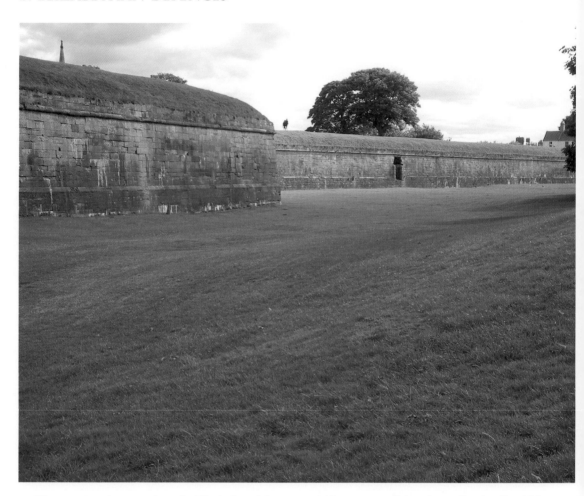

5a. We now enter the area where the Elizabethan defences overlaid or ran parallel to the medieval wall, which is still visible for part of its course. Before this, major artillery works were added to it in the reign of Henry VIII, and Edward VI began to build a square citadel across the medieval wall to the east, but only the plan of the latter remains. The medieval wall runs up to the bastion, seen here coming from the right as a slight rise in the grass.

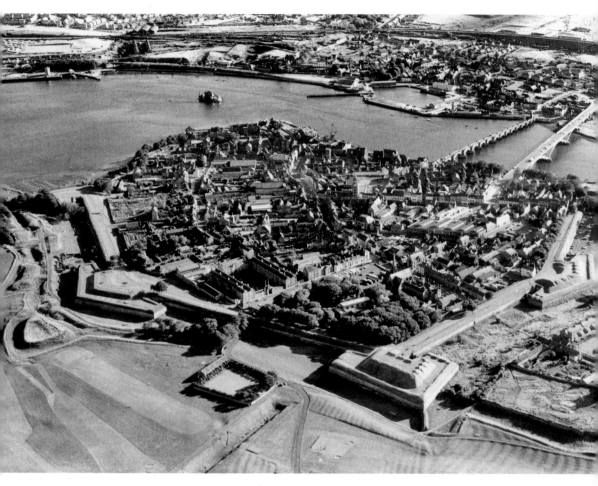

5b. Air photograph. (*Newcastle University*)

When faced with the scale of the Elizabethan defences, many people may not be aware of the defences' medieval predecessors. The later developments are an outstanding example of military architecture in which guns have played a dominant part. Artillery had developed to such an extent that older defences were inadequate to face it.

Berwick shows how much had been learnt from Europe. Additions had been tried, but the new plan was much more comprehensive. Such innovations were becoming known and put into practice in Henry VIII's reign, but it was Elizabeth who grasped the nettle, incorporating, at great expense, the latest strategy and technology in this defence against the Scots and their allies the French. The first thing to notice is that, like the medieval defences, they cover a wide area, taking in the whole town, but leaving out the northern parts with the castle and medieval walls.

We see the town from the north-east, with the medieval wall coming in from the bottom right corner to meet the Brass Bastion, to the right of which the rampart runs west to include the central Cumberland Bastion and Meg's Mount.

To the left, the central Windmill bastion stands out, pointing seawards over the Windmill Bulwark, an echo of its shape. From there the defences run to the river and follow the medieval line.

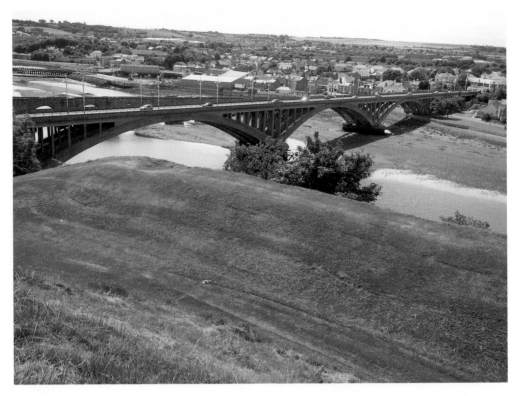

6a. Building began on the north face, with a central bastion flanked by two others on the east and west. To the west is Meg's Mount, overlooking the river and modern road bridge.

6b. Next in line is Cumberland Bastion, like an arrow pointing north, with this large platform.

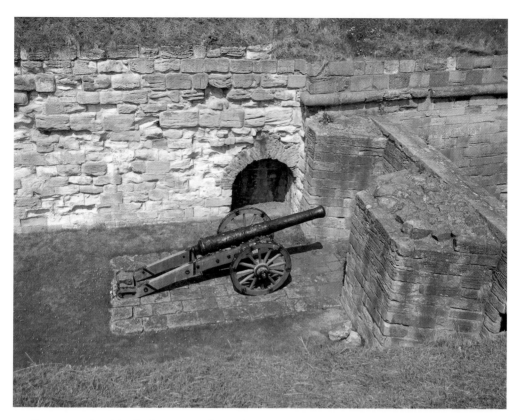

6c. Guns were placed in 'flankers' to catch attackers as they approached the walls in cross-fire.

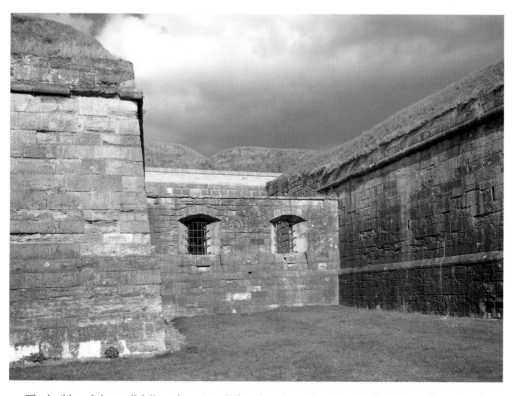

7a. The builders did not all follow the original plan though, so Brass Bastion is different from the others. Seen from the west, the gun ports are concealed.

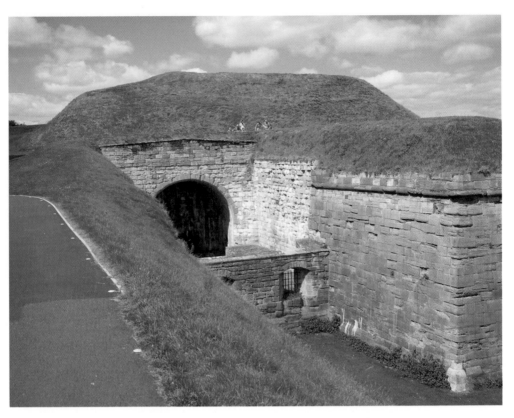

7b. Brass Bastion with its additional earthworks on top, seen from the south.

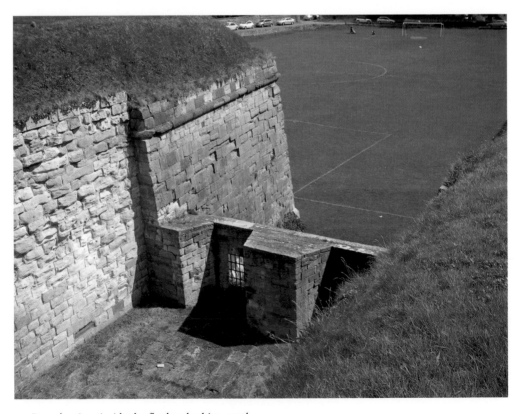

7c. Brass bastion: inside the flanker, looking south.

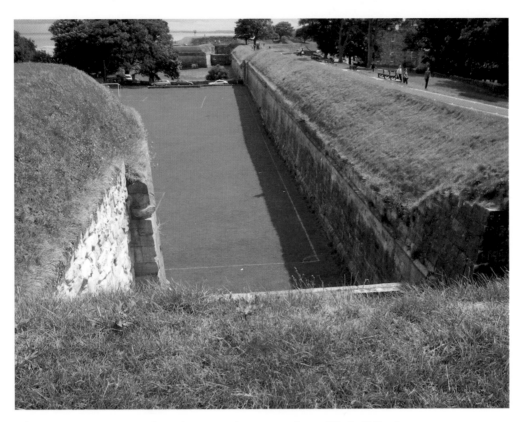

7d. From Brass Bastion, south, to the next major construction at Windmill Bastion.

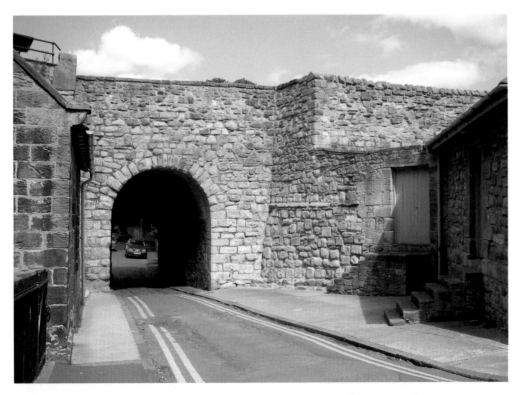

8a. Gates were needed through the wall, and this at Cowport, seen from the inside, runs as a tunnel under the rampart wall.

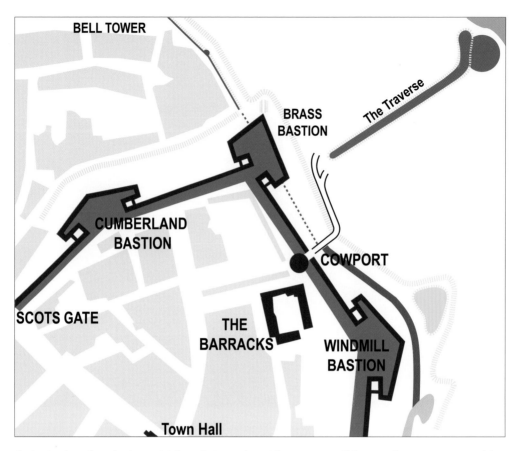

8b. Again, the value of information boards is seen here. There was an offshoot to the sea across Magdalen Fields called The Traverse, but the main defence lay in the new wall.

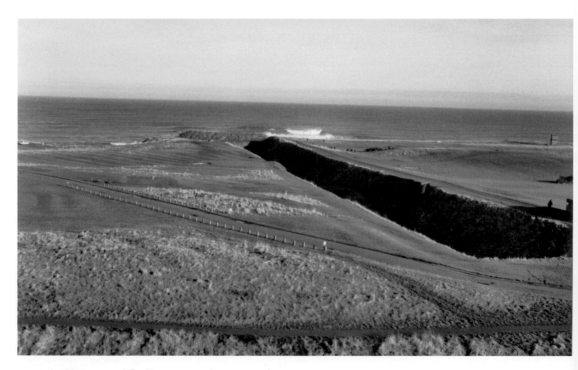

8c. Here we see The Traverse running east to the sea.

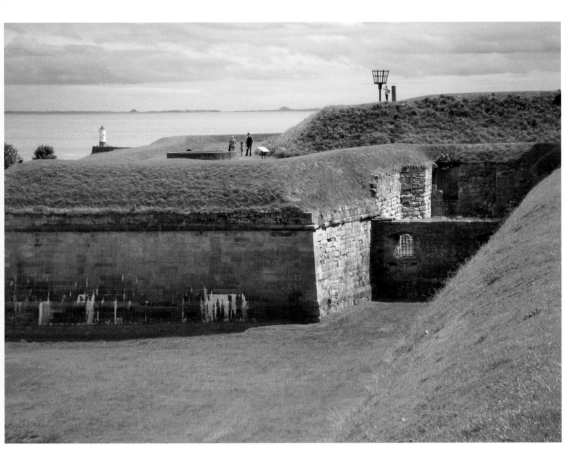

9a. The Windmill Bastion from the north.

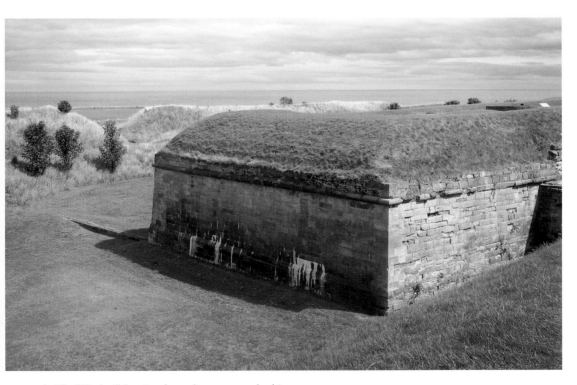

9b. The Windmill bastion from the ramparts, looking to sea.

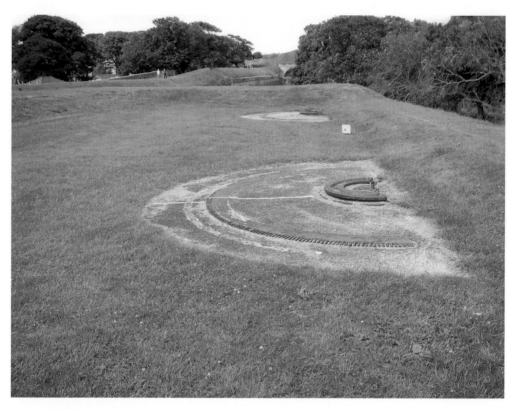

9c. The Windmill Bastion has gun mountings that were added from the nineteenth century to the First World War. Here we see some of them.

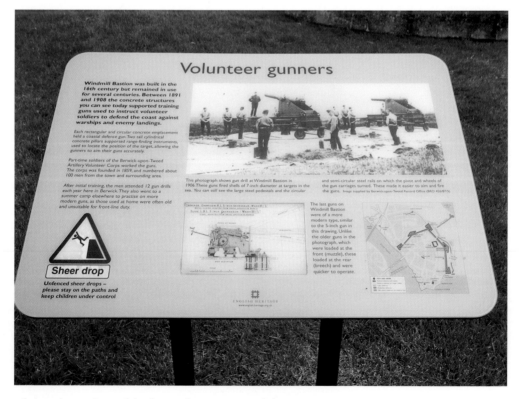

9d. A notice on site explains how volunteers manned the guns.

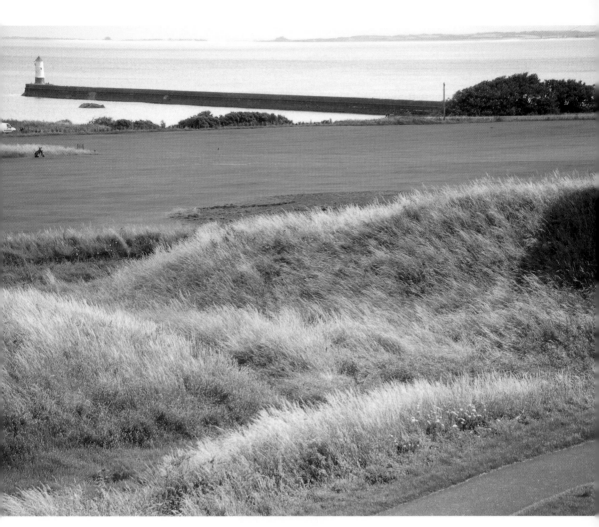

10a. Beyond this Bastion to the east there are earthworks that were superseded by the stretch of wall from the Windmill Bastion to King's Mount. Among them is the proposed but abandoned citadel of Edward VI, but the earlier earthworks still run parallel to the Elizabethan east wall.

Here are three pictures of the medieval earthworks, the first with the pier and lighthouse beyond.

10b. The earthworks east of Windmill Bastion.

10c. The site of the Edward VI's uncompleted citadel.

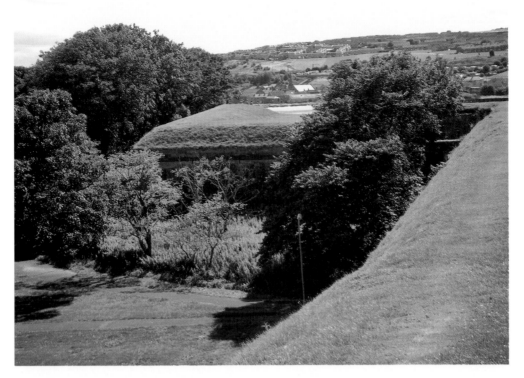

11a. King's Mount is the last bastion, but it was unfinished. Here it is seen from the north.

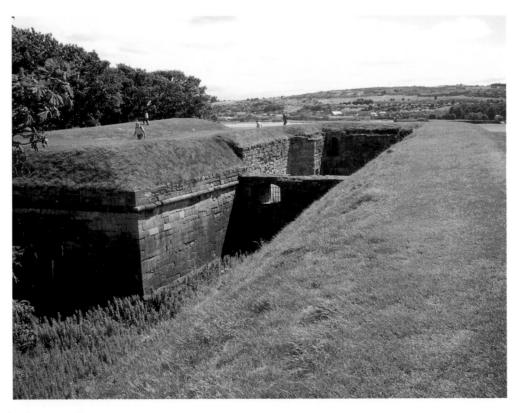

11b. King's Mount.

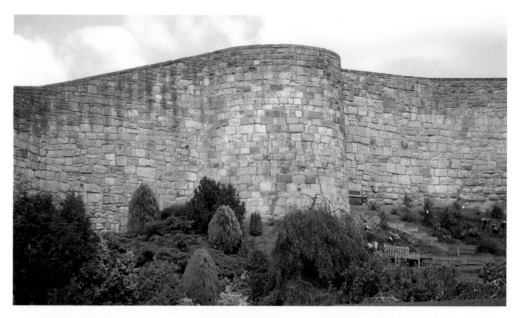

12a. This semi-circular tower lies at the end of the medieval walls before the river is reached. From here the walls follow the river bank.

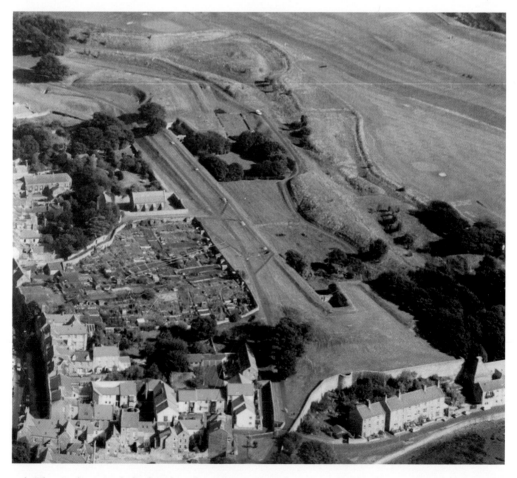

12b. The air photograph displayed on the site notice board is an invaluable aid to see the whole site. The semi-circular tower is at the bottom.

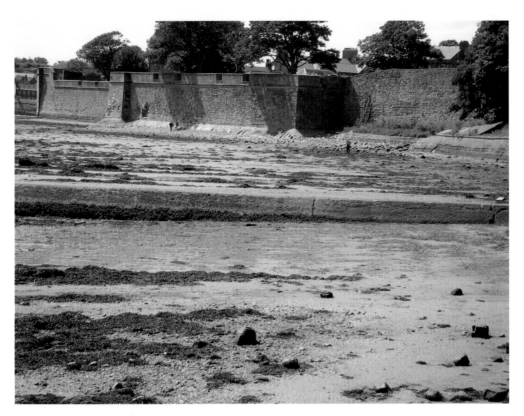

13a. The walls seen north from the river bank.

13b. The line of the defences then follows the medieval wall to Fisher's Fort, with its present relic of the Crimean War built on it. The tower was built in 1522-23, and partly rebuilt in the eighteenth century.

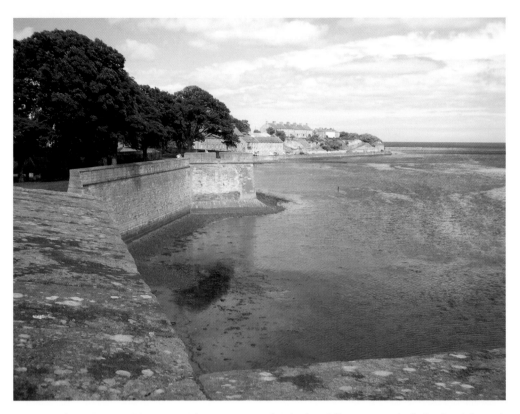

13c. East from Coxon's Tower to Fisher's Fort. Much of what follows was rebuilt in the eighteenth century.

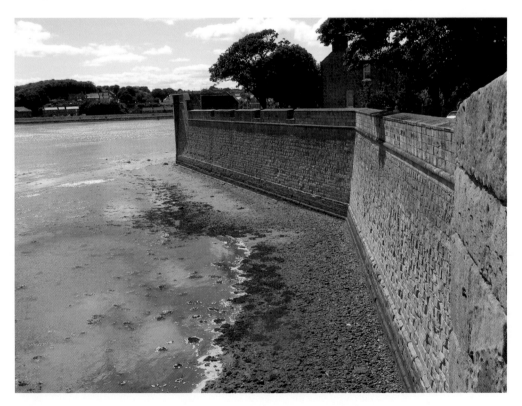

13d. Coxon's Tower has a fourteenth-century vault, but the rest is rebuilt.

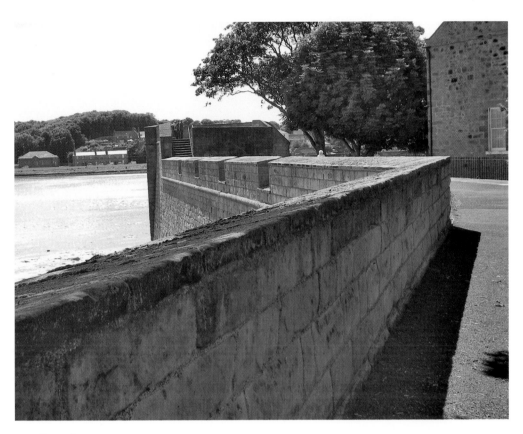

13e. Coxon's tower.

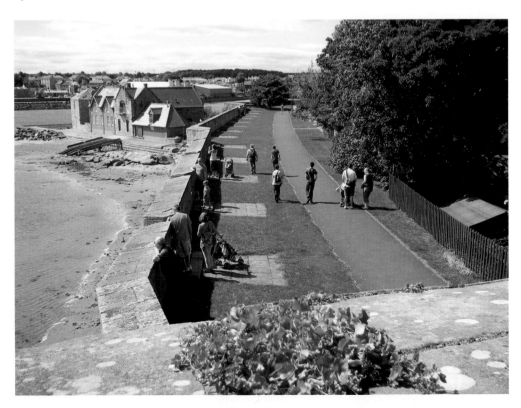

13f. North-west, then north from Coxon's Tower. Most of what we now see is Georgian.

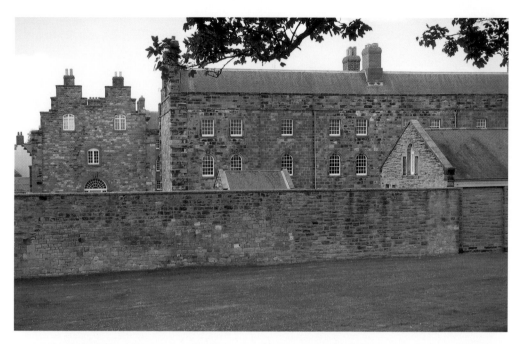

14a. and 14b. The barracks were occupied in 1721. The arms of George I decorate the main gateway.

Before this, there were many changes, such as in the English Civil War, when in the early Cromwellian period it became an important fortress. During this time the very unusual Commonwealth parish church of Berwick was built. All around the Elizabethan ramparts from 1639-53 earth was piled on top of the bastions and platforms built as gun emplacements on them.

In particular, the Jacobite rebellions of the early eighteenth century caused alarm.

So these events and other rebuilding led to what we see today, and a notable final addition was the building of the Ravensworth Barracks.

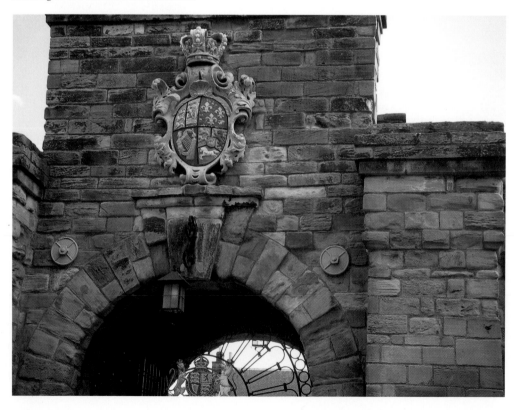

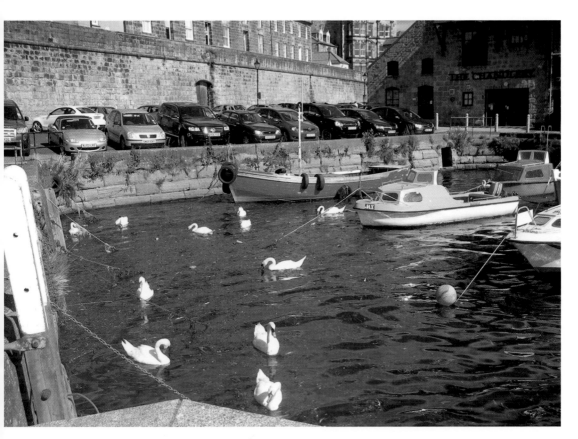

15a. Quayside swans and walls.

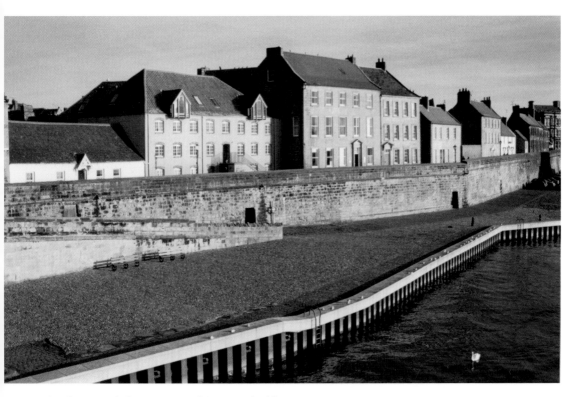

15b. The quayside has an array of Georgian buildings.

15c. The walls continue north to reach the rail bridge and the Water Tower, completing the circuit.

HOLY ISLAND CASTLE

1. The Holy Island causeway. The island is far from the mainland, cut off rapidly by tides, so that access was by a causeway open only for a while. This made the castle somewhat remote from what was happening on the mainland but emphasised that its function lay seaward, to fire on hostile ships and to guard the harbour. It was a gun-platform with accommodation.

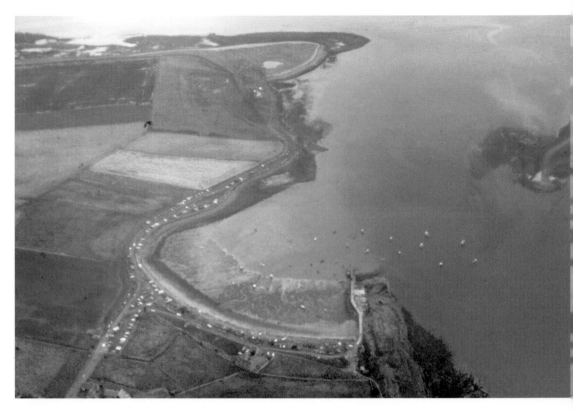

2. The harbour is a rounded bay, leading to the castle ridge.

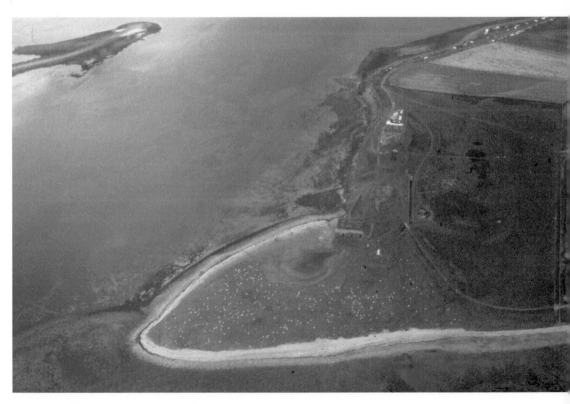

3. From the sea we see the waggonway skirting the coast, used to bring limestone from the island's quarries to the kilns, above which is the castle.

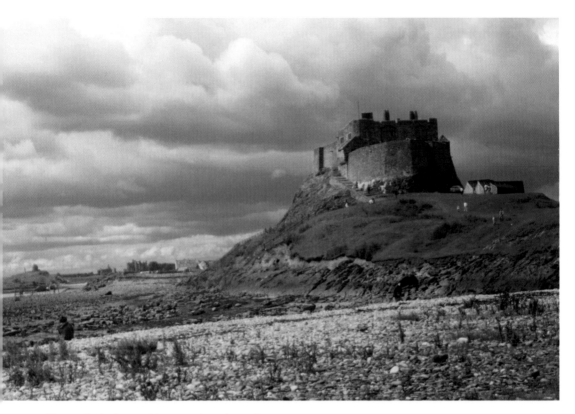

4. The castle, built on whinstone, rises above the coast.

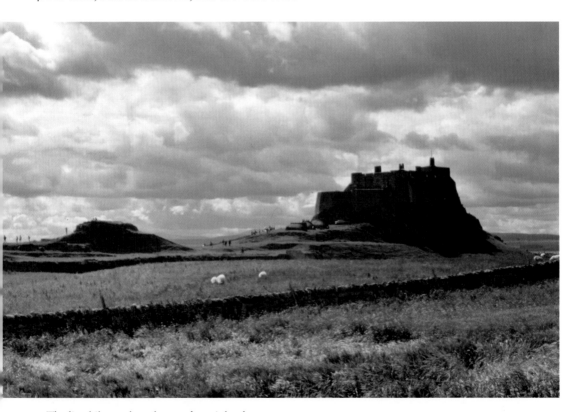

5. The limekilns and castle seen from inland.

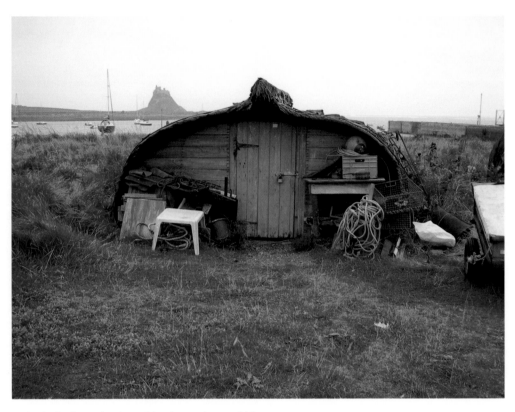

6. At the harbour, dominated by the castle, an old boat serves as a store.

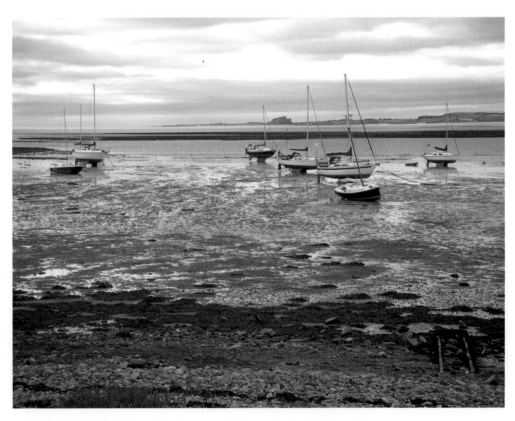

7. Bamburgh Castle is seen on the horizon, with boats beached at low tide.

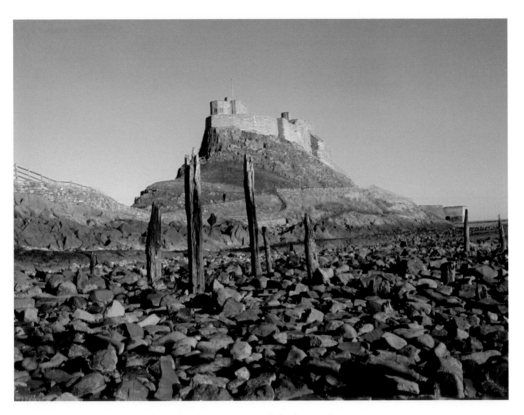

8. All that remains of a wooden jetty that once served the lime industry.

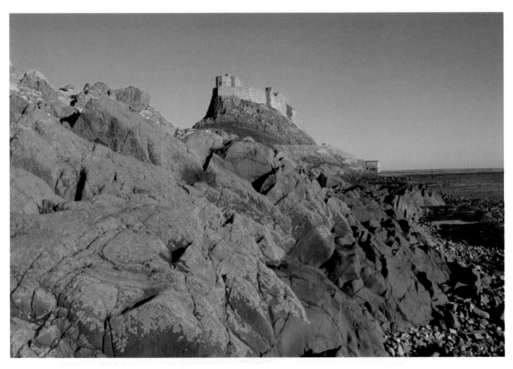

9. Like Bamburgh and Dunstanburgh, the castle is based on pillars of basalt, here covered with lichen, which gave it a good view in all directions. The hill on which it stands was called 'Beblowe' in 1550, which may come from 'low', locally meaning a hill, and be named in the same way as Bamburgh from Bebba – but this is speculative.

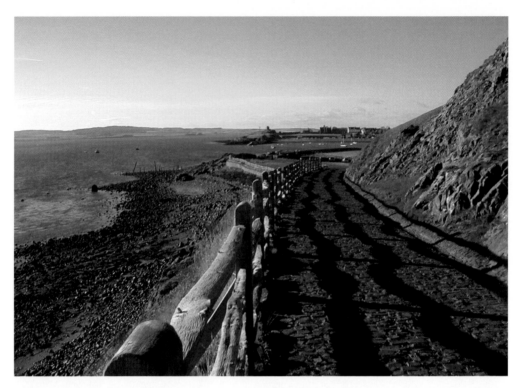

10. The approach to the castle from the harbour. Unlike the other castles, it was not built until 1543, and there is no evidence for anything earlier on the site as the castle and limekilns cover it.

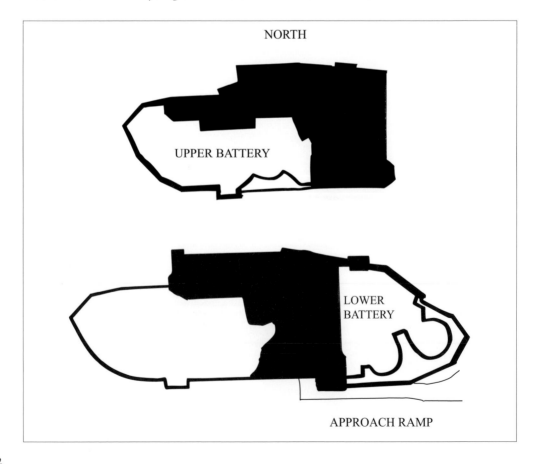

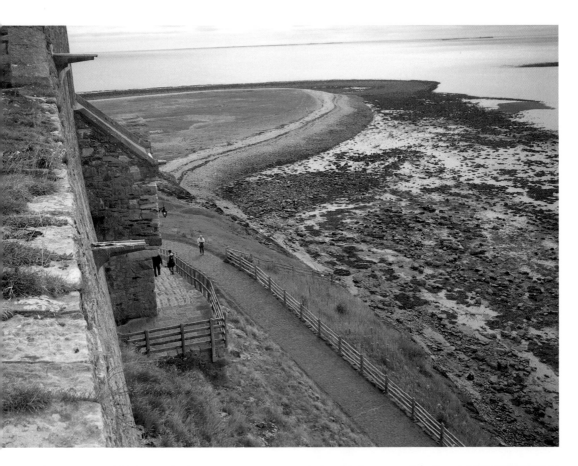

Above: 11. A cobbled ramp leads to a portcullis entrance, from which there is access to the open-air Lower Battery – a gun platform.

Right: 12a. Today's entrance from the outside.

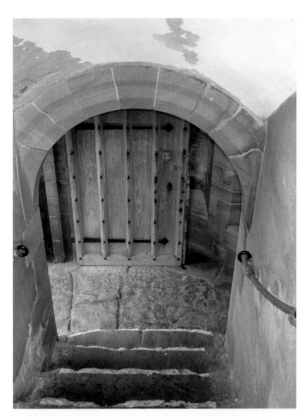

Left: 12b. The entrance from the inside.

Below: 13. What we see today is a well-executed restoration in which the weakest part, the interior, was refurbished with the help of an outstanding architect, Sir Edwin Lutyens. This preservation continues under the National Trust, which acquired it in 1944. An attractive brick herring-bone floor is an example of Lutyen's work.

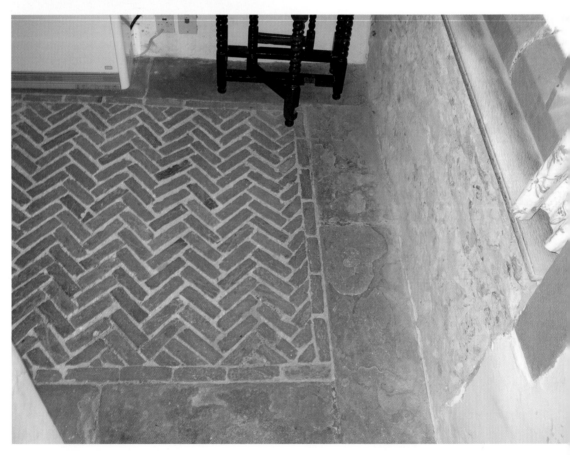

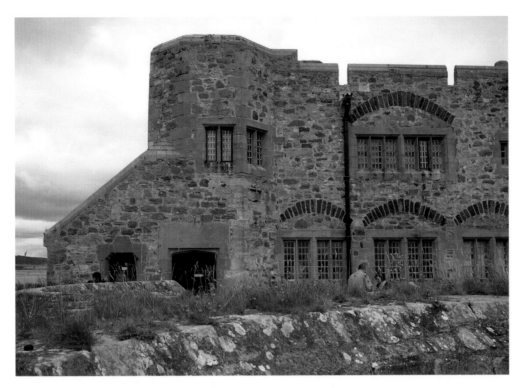

14. The castle stands like a battleship with a pointed prow on the crag, and its main weapon was artillery in two batteries of guns on two levels. The Lower Battery, for artillery, is reached from today's entrance, with this range of buildings backing onto it.

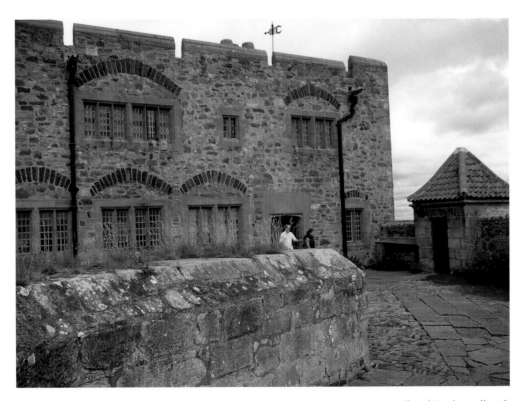

15. The wall has been restored and behind it are the Ship Room, Dining Room, Hall and Kitchen, all with different functions from the original which involved housing a garrison and its ammunition.

16. The view is eastward from the guns. The castle was close enough to Scotland to support troop ships; for example, in 1543, an English fleet used the harbour to land troops to march to Berwick.

17. A second gun emplacement. The castle fortunes fluctuated; the peace that came when James VI of Scotland became James I of England in 1603 saw it fall into decay, but threats from the Continent revived it. In the Civil War it passed from Royalists to Roundheads – like Berwick – but after that there were only seven men in the garrison. In 1820 the guns were finally removed, and the castle became a coastguard station.

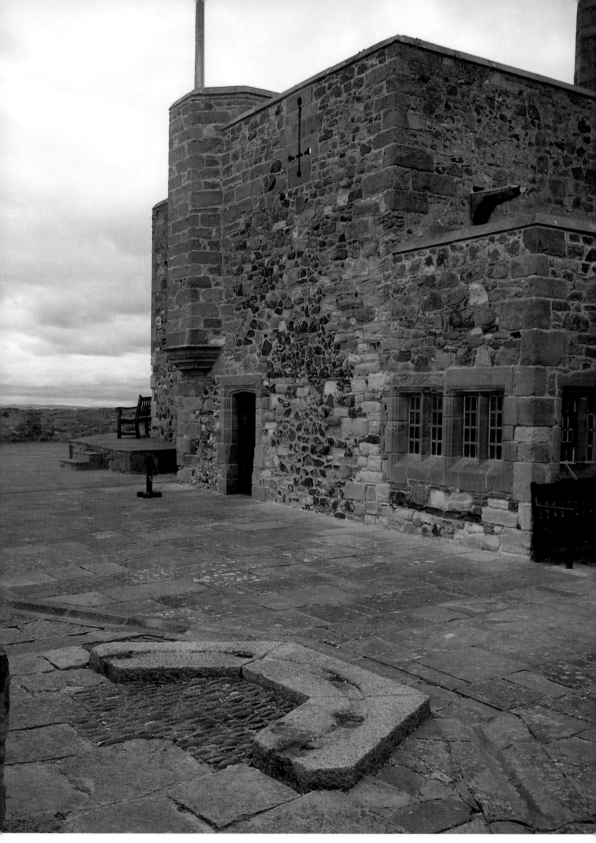

18. There is solid stonework throughout, and to reach the second floor and the Upper Battery we ascend a curving stone stair which is original. This upper level stands well above the rest, and now houses a Long Gallery and three bedrooms. The gun emplacement remains in front of the West Bedroom tower.

19-22. This and the following pictures show the stonework of the Upper Battery which has a variety of sandstones in it, including Lutyen's pink sandstone for more delicate work.

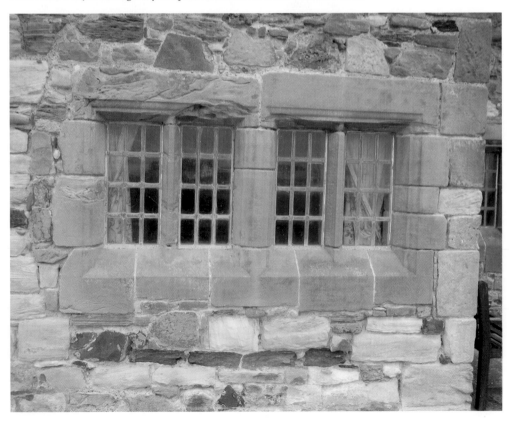

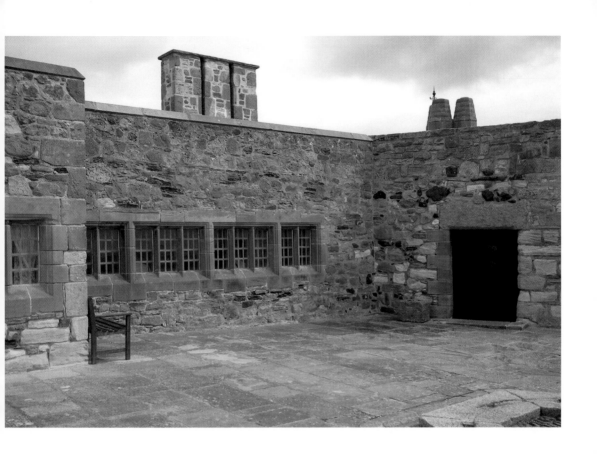

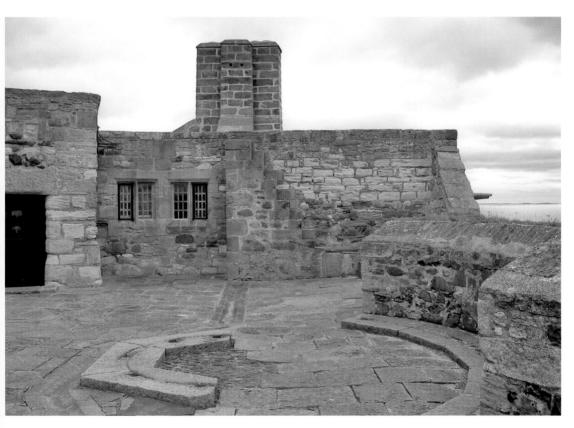

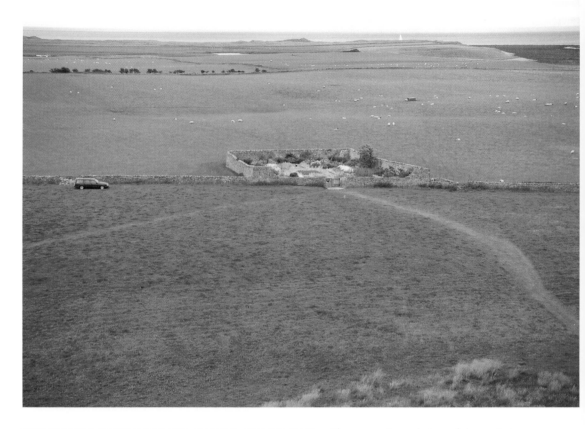

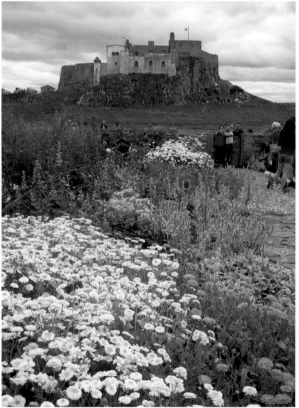

Above: 23. A good view of the castle is from the Gertrude Jekyll garden, laid out in 1911, shortly after the castle was converted into a residence. She had a close working relationship with Lutyens in the design of other national gardens and houses. Here we look down from the castle.

Left: 24. In summer there is a colourful display within the walled garden, in contrast to the surrounding greens.

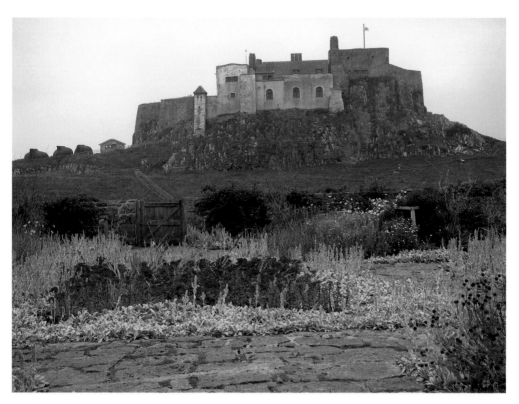

25. The garden has plants for all seasons. The light-coloured castle wall beyond has been recently re-surfaced by the National Trust, using traditional materials and techniques.

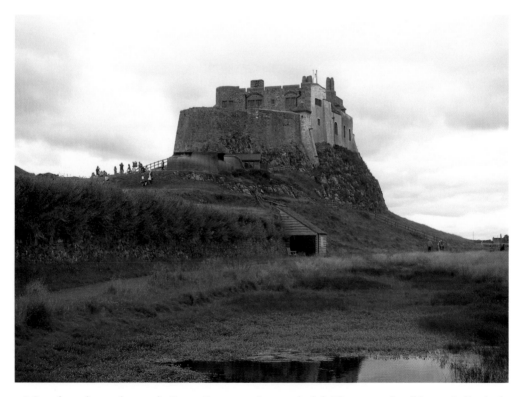

26. Seen from the north-east, the Lower Battery projects to the left. The renewed wall has an Italian look.

27. Sharing the promontory with the castle are nineteenth-century limekilns and a waggonway overlooked on the seaward side; the lime and coal were brought to the top of the hill and emptied into the large, tunnel-like kiln chimneys.

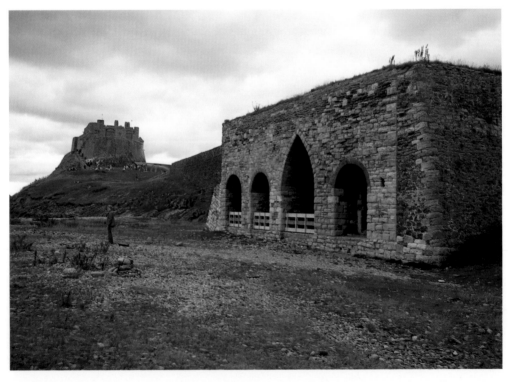

28. The kilns, built by a Dundee company in the 1860s, have a cathedral-like appearance that goes well with the castle.

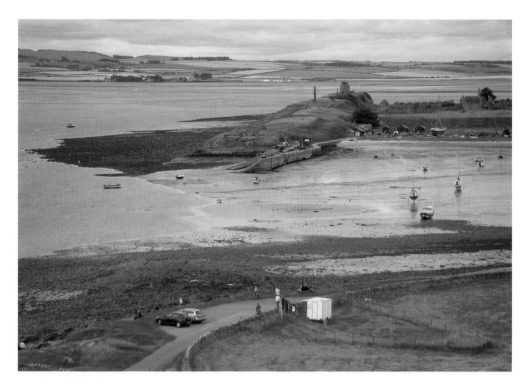

29. The views inland show how the basalt ridge continues on the other side of the harbour; known as the Heugh ('cliff') it overlooks the Priory, and this ridge was used for the building of a minor fortification overlooking the harbour in the late seventeenth century, though little is left of it. On the same ridge is a war memorial designed by Lutyens.

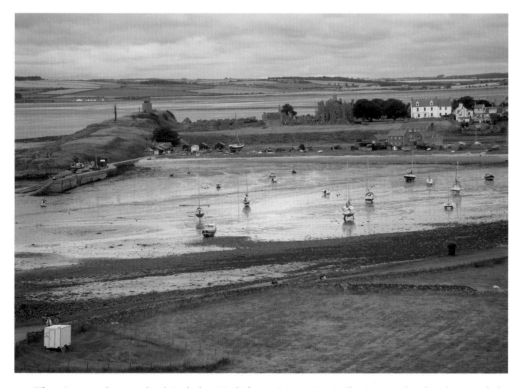

30. The view to the mainland includes Lindisfarne Priory. Ironically, it was the dissolution of the monasteries that provided material to build the castle, for the priory was built of ready-made cut stone.

31. Further west are the Cheviot Hills, seen on the horizon.

BAMBURGH

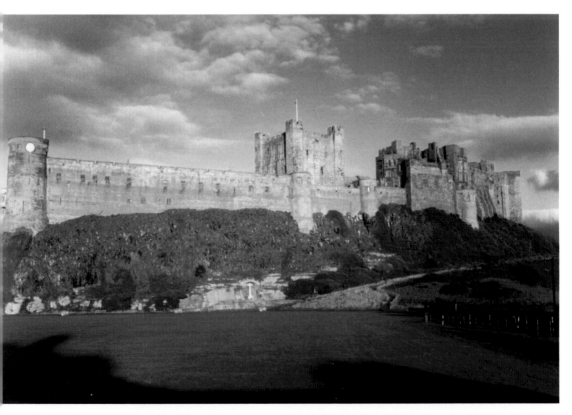

1. Most people's perception of Bamburgh Castle is of the great wall of red/orange sandstone that changes colour with the natural light, rising above vertical columns of whinstone. It is built on a grand scale, following as it does the length of the volcanic outcrop and crowning it.

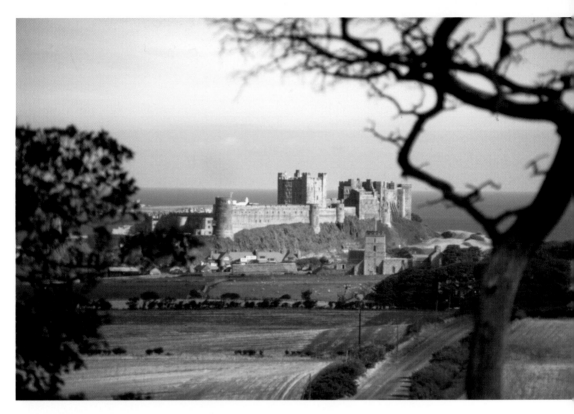

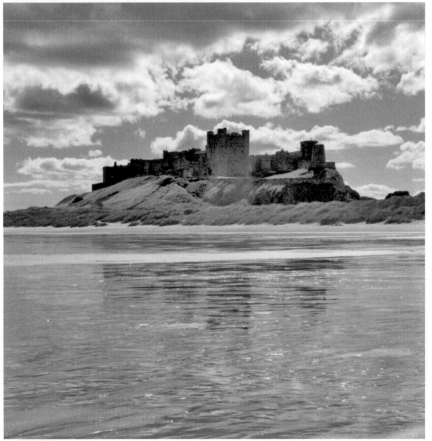

Above: 2. From a distance it can be seen miles away, because it is raised above the coast both naturally and artificially.

Left: 3. The position of the castle close to the sea is reinforced by the reflections that it sometimes makes in the water.

4. From the north there is a long stretch of superb beach at Ross Links, ending at the Warren Burn estuary, after which the whinstone-dominated land takes over.

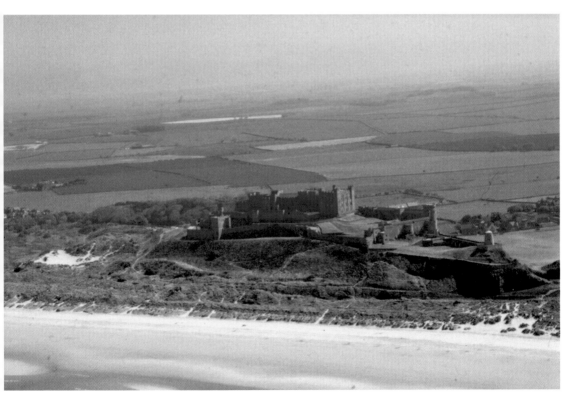

5. From the sea and dunes beyond, the basalt rises with the castle spread along the top.

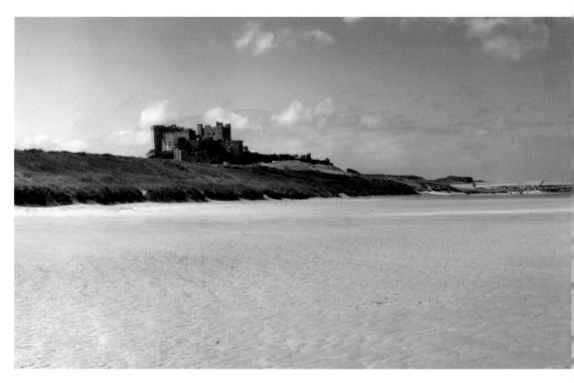

6. With the tide out, the sandy beach is extensive.

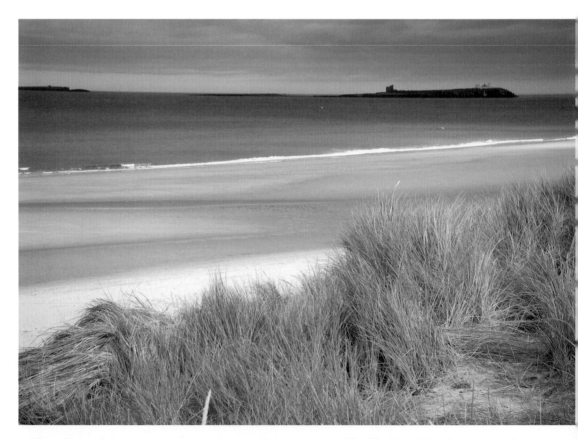

7. The colours of the marram grass, sand, sea and sky change rapidly. The Farne Islands appear to have a Mediterranean setting.

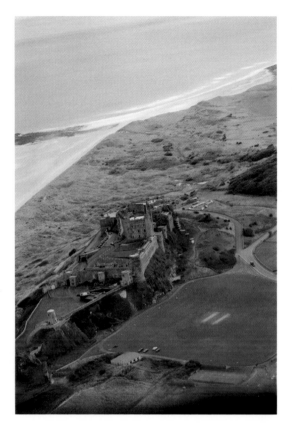

Right: 8. A flat cricket field separates castle from the village, which is largely modern, but overlooked from the west by an ancient church. The village appears at the bottom right of the picture, looking over the cricket field and castle to the sea. (*Gordon Tinsley*)

Below: 9. The cricket ground and part of the village, seen from the castle, leads to St Aidan's church, founded in the twelfth century.

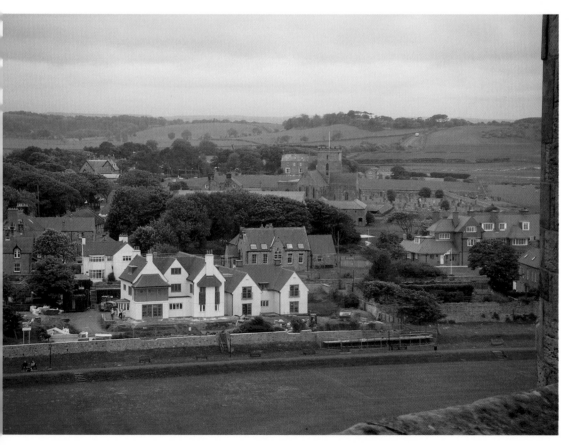

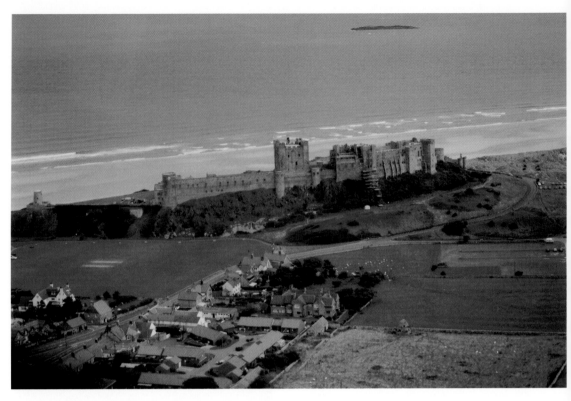

10. A reminder of the past is a dovecote in the fields that back onto the village which are rig and furrow ploughed. (*Gordon Tinsley*)

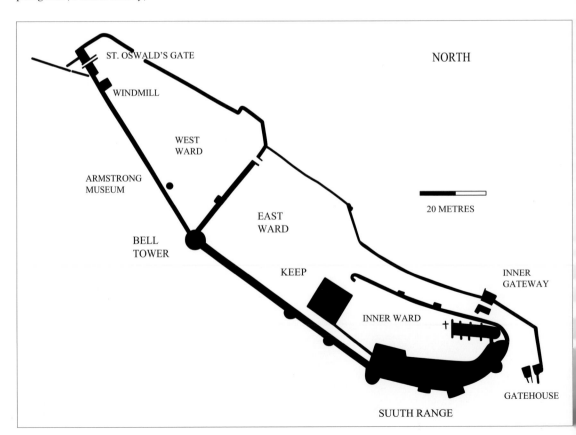

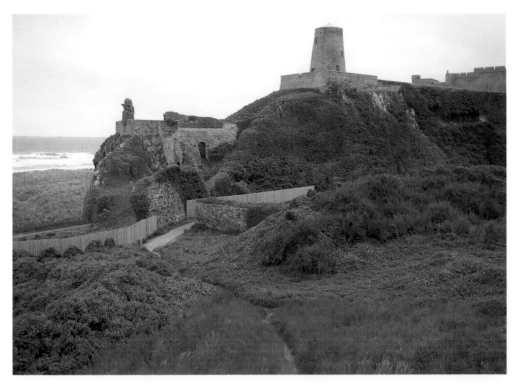

11. The west end of the castle had access to sea and harbour through a narrow fortified gate, named after St Oswald, and a postern tower that leads to steps cut into the whinstone. To the right (east) is an eighteenth-century corn windmill. The wall separating West and East Wards is on the extreme right.

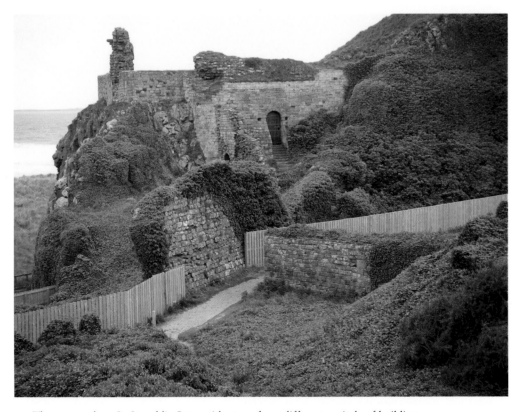

12. The approach to St Oswald's Gate, with stone from different periods of building.

13. On the horizon is a ridge of whinstone, and in the foreground is the probable site of the harbour.

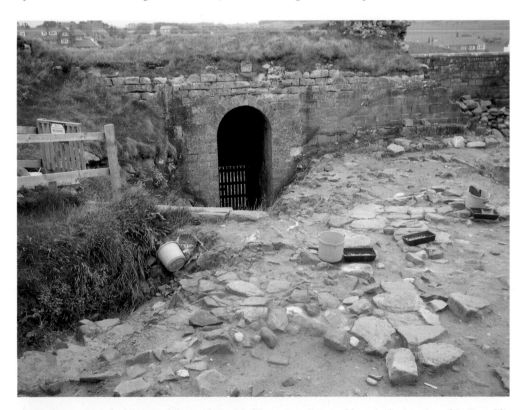

14. Understanding the history of the castle is aided by excavation, and here is the interior of St Oswald's Gateway with complex features that are being methodically revealed. The picture was taken during a break in the excavation in June, 2010.

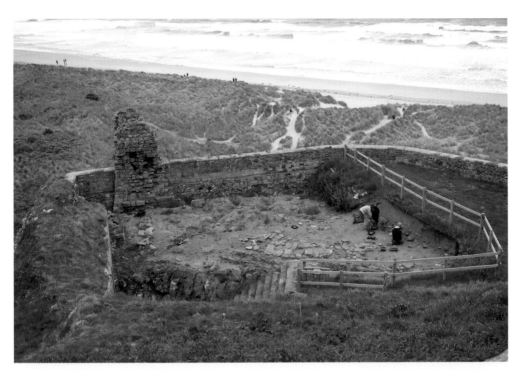

15. The western excavation is by the wall that overlooks dunes and sea. The thickness of the sand that covers the base is seen to the right. A fragment of a possible tower is seen on the wall to the left, and a lower phase of the wall. Known medieval masonry houses the entrance, present since the eighth century, but reconstructed many times.

16. A view of the tower fragment, right, the rebuilt eighteenth-century wall top, the gateway and the village beyond.

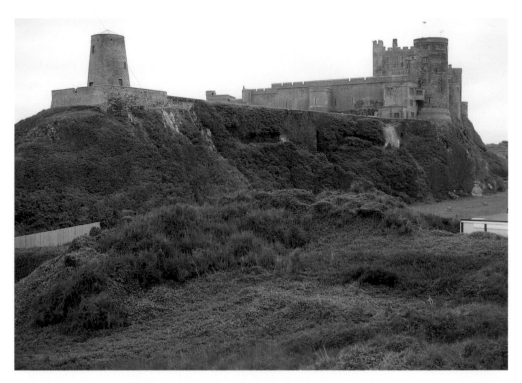

17. The next feature on the basalt ridge is the eighteenth-century windmill, the modern wall between the West and East Wards, a clock tower, and the keep rising above all.

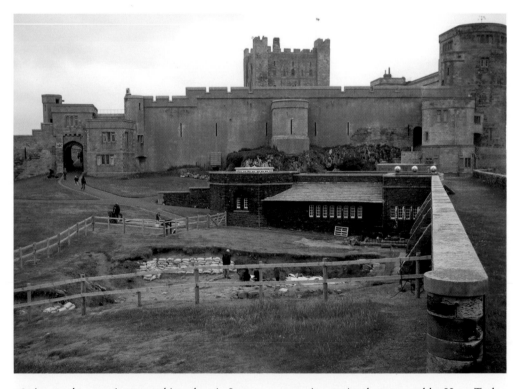

18. A second excavation was taking place in June 2010 on a site previously excavated by Hope-Taylor, where there is rare evidence of life in the Anglian period. The trench is next to the basalt-built Armstrong Museum and rooms which housed the late excavator's finds and archive, now re-examined and updated.

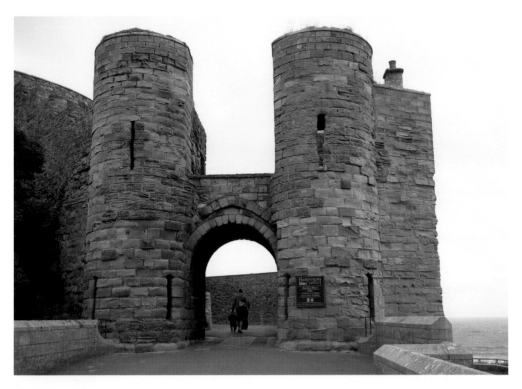

19. We leave the St Oswald's entrance and its immediate area to enter through today's visitor entrance, the Great Gate at the east end. These round flat-backed towers with an arch between them are partly Norman.

20. The arch is tunnel-vaulted, with a portcullis slot.

21. The stone has eroded, with some of it like the sandstone at Dunstanburgh, full of holes.

22. From inside, the Great Gate leads into a sunken road protected by walls of natural rock and masonry.

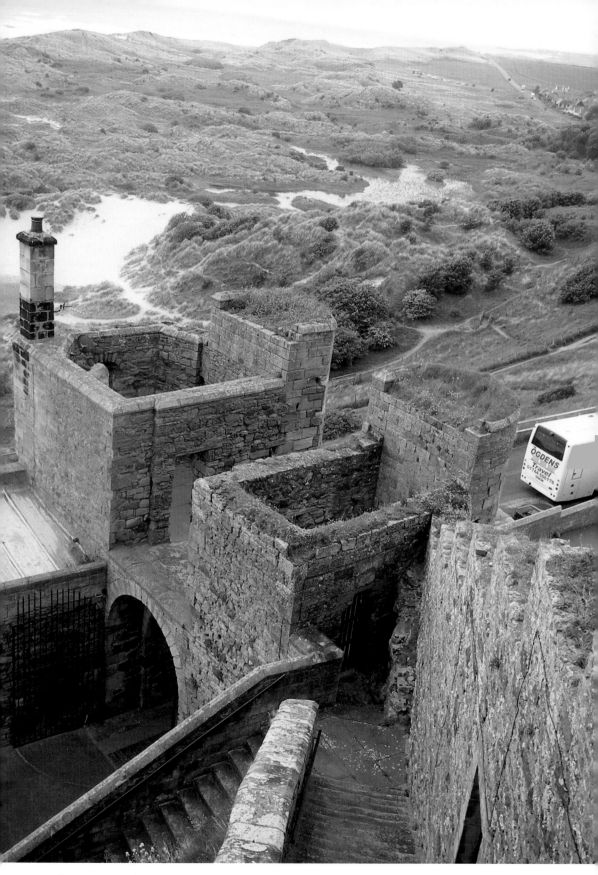

23. The Great Gate from above, to the dunes and sea.

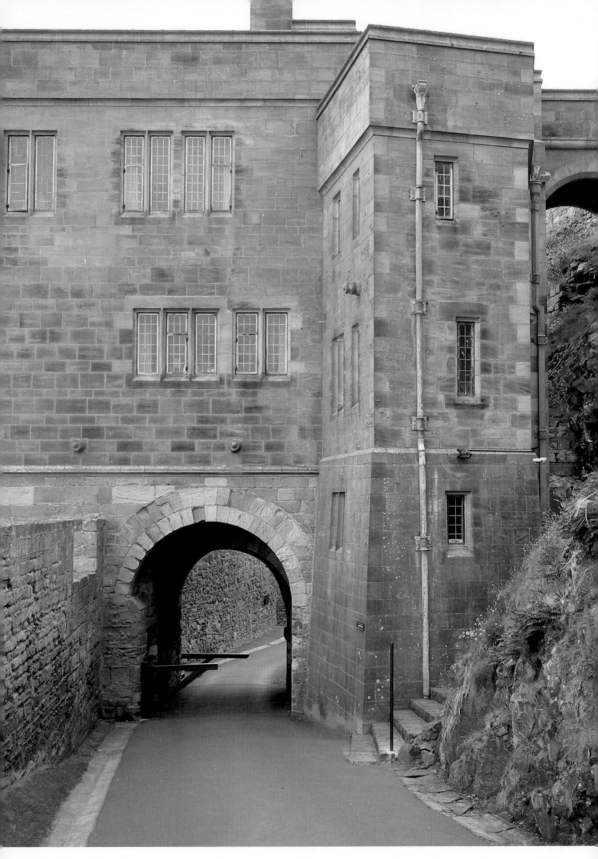

24. The road turns, then enters an Inner Gateway, now used to issue tickets, where the masonry is clearly nineteenth-century, although the vault is twelfth-century. To the right is a basalt outcrop.

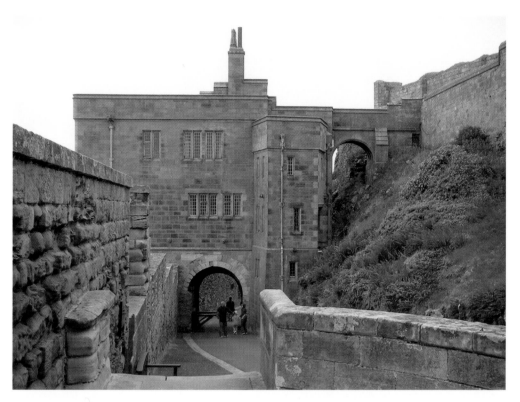

25. Rock rises steeply to the right to the wall of the Inner Ward. The red sandstone side walls, left, have a medieval foundation.

26. A study of stone makes the history of the buildings clearer. Here the machine-cut, light-coloured sandstone is a modern construction.

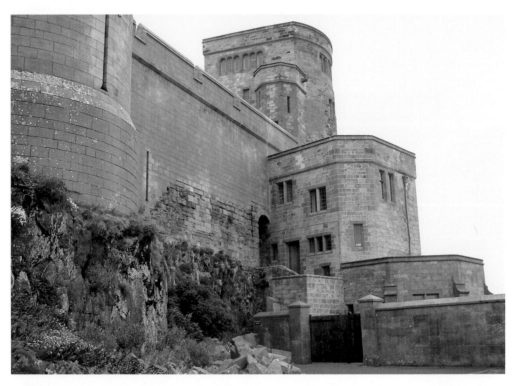

27. The wall that separates the East from the West Ward, seen from the west, is an interesting mixture of medieval red sandstone on basalt, capped by modern stone that has been given variety by using colour in quoins and around windows.

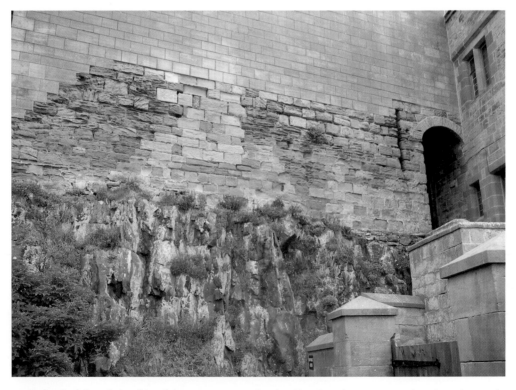

28. A detail of the relationship of these stones to each other. Leaving plants to grow there is a nice touch.

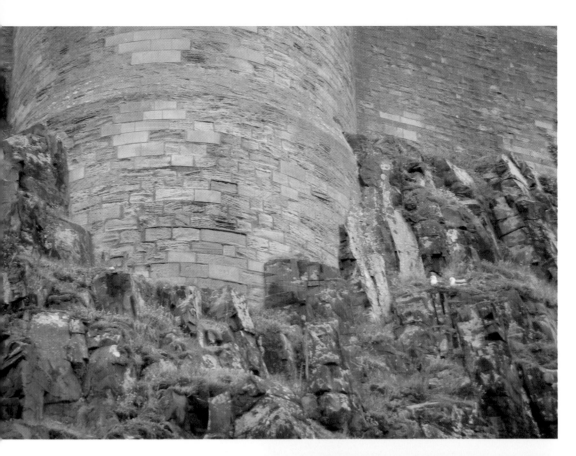

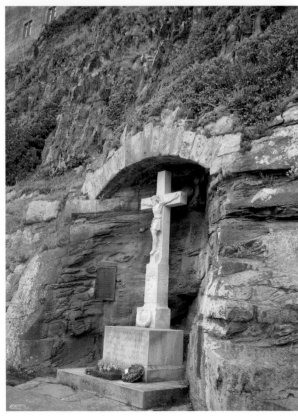

Above: 29. On the south side, the effect of building into basalt is dramatic. A round tower protrudes from the wall, generally a later phase of castle-building, rebuilt later.

Right: 30. Below the castle wall, this war memorial has been inserted into a niche cut out of the natural sandstone that underlies the basalt.

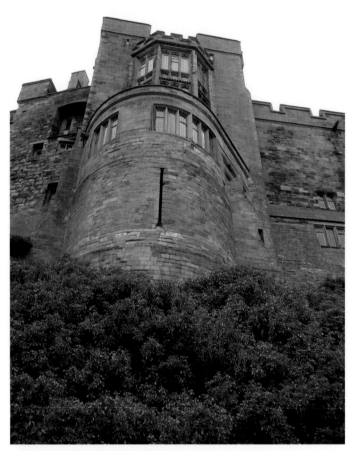

Left: 31. Another round tower is used as a base for further building that lets in light through a splendid bay window set in a square tower.

Below: 32. This view over the south wall shows the keep rising above other buildings, to the east (right) of which is a range that includes towers, a hall and kitchens. Above these is the north wall, to the right of which is a rectangular building that was a chapel. (*Gordon Tinsley*)

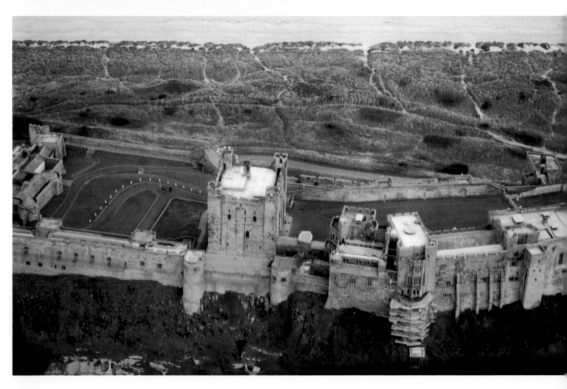

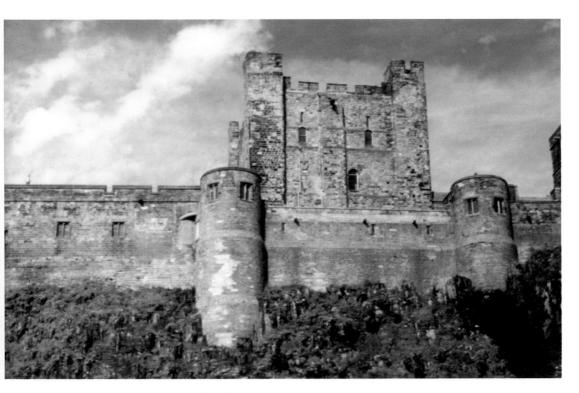

33. The keep from outside the south wall.

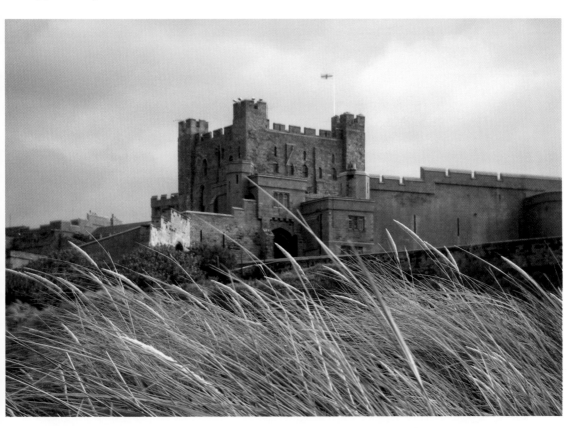

34. At the heart of the medieval castle is the Norman keep, seen from the dunes, rising above the wall and between the Wards.

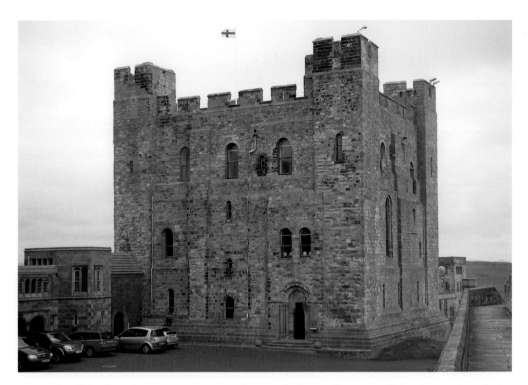

35. Bamburgh has been for centuries a centre of power for local rulers – a tradition that continued with the Norman Conquest, when Bamburgh became a royal castle. The square keep was its centre, but the strength of the curtain walls was its first line of defence. It was built in the high Inner Ward in the twelfth century and has survived well. Battlements and big windows have been added, but the exterior is well preserved. The inside has been considerably changed.

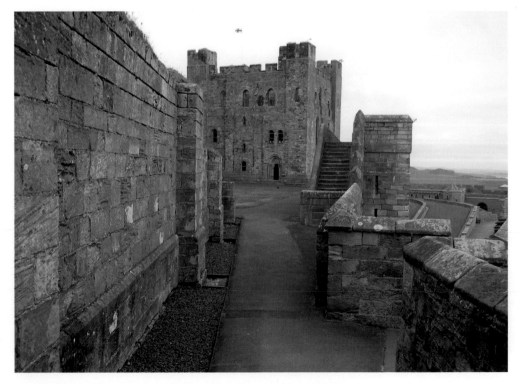

36. The keep, looking west, from the north chapel wall, has three floors.

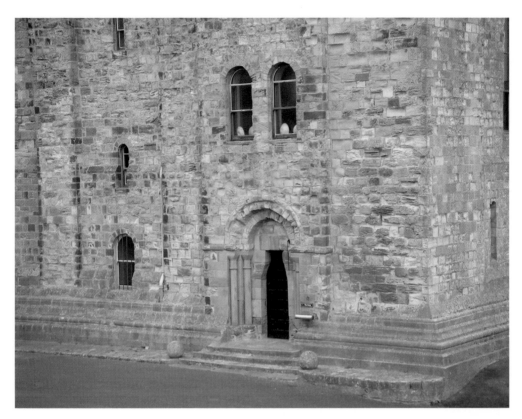

37. The keep doorway, with repairs, retains its Norman structure.

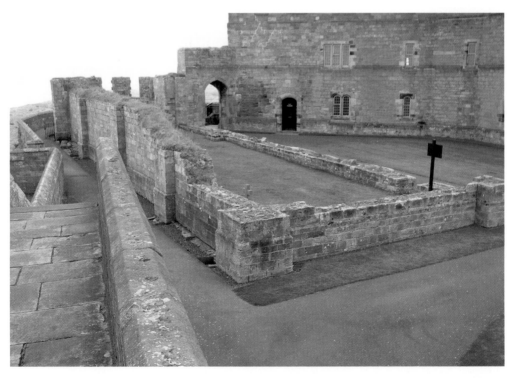

38. Church and state were in close alliance; here is the foundation of the Norman church built to the east of the keep and close to the hall buildings. The walls are nineteenth-century, built on old foundations, but the earliest visible Norman survival is the apsidal east end.

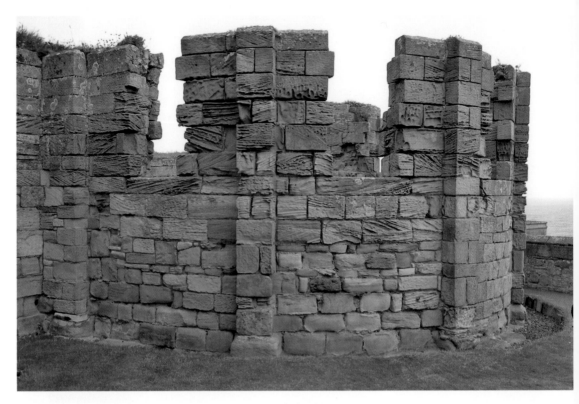

39. On the outside the apse has some original stone, with thin buttresses.

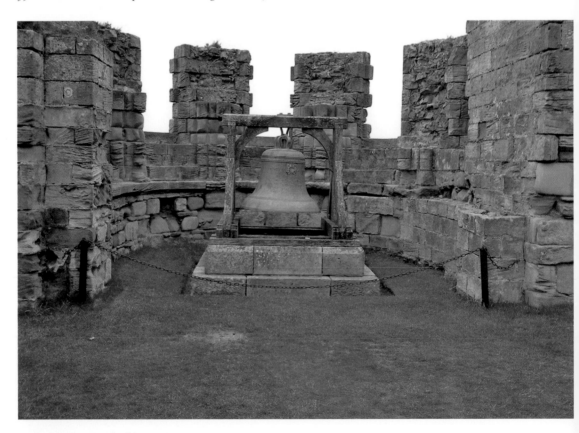

40. Inside the apse, looking east.

41. A detail of the apse's recessed windows and the fascinating eroded sandstone.

42. The south and west walls of the church in the Inner Ward, with the keep to the west and a range of buildings, modern on the outside, but on ancient foundations, to the south (left).

43. The money poured into the reconstruction of the Hall buildings during the eighteenth and nineteenth centuries has produced something that only in part echoes what the medieval range would have looked like. For the original we have to look deeper to see the Great Hall and The Captain's Lodgings, to the east of which were the kitchens, Muniment Tower and Davie Tower that run up to the east church and Great Gate. In contrast to the Norman survival, the buildings along the south wall, which display from the outside some elegant and elaborate bay windows, are very modern renderings of an earlier style. There is little left of the earlier buildings; the Hall is on the site of a Great Hall built by Sir John Fenwick between 1380 and 1390, and there are medieval cellars. One wall of the modern façade is covered with coats of arms, and visitors today enter the Great or King's Hall to view rich interiors with rich displays of objects collected by rich people. Suits of armour and weaponry are prominent. There is pottery, furniture, paintings and other objects of interest, but these illustrate periods rather than coming from the castle itself. It is because the castle came into the hands of a Prince Bishop, and then into the hands of a highly-successful industrial innovator, that we are able to see such elaborate buildings and their contents.

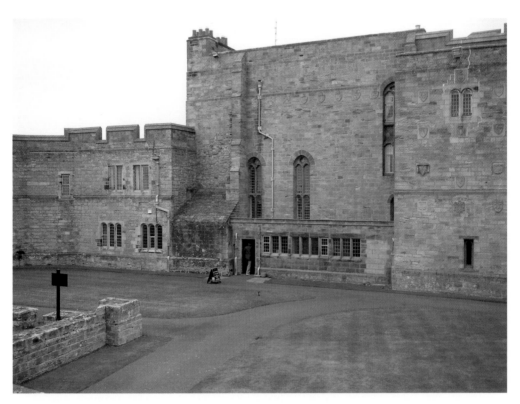

44. The narrow visitors' entrance leads into what is on display to the public.

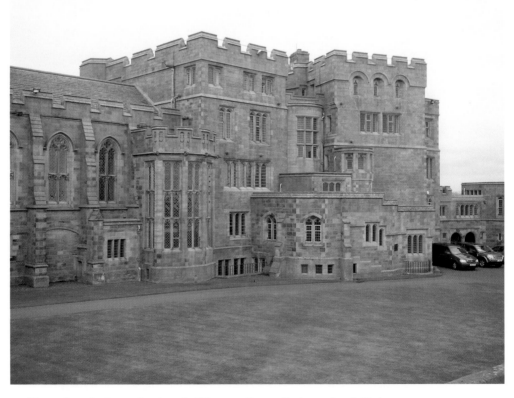

45. The main style chosen for the rebuilding was Perpendicular and early Tudor.

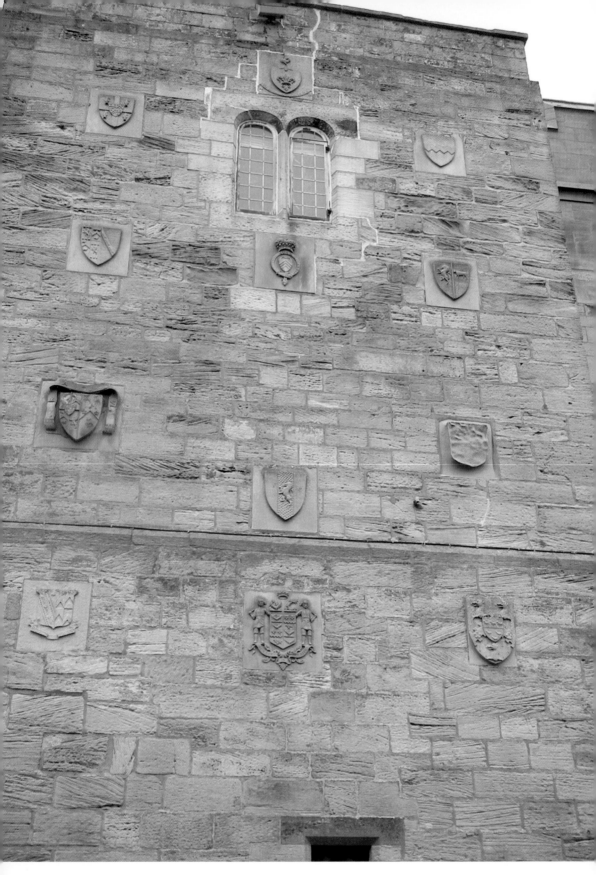

46. Detail of the coats of arms.

47. The Inner Ward is separated from the West Ward by another modern row of buildings including a Clock Tower and Stable Block. Here, as elsewhere, we are reminded that there are apartments within the castle, some with the right to park cars.

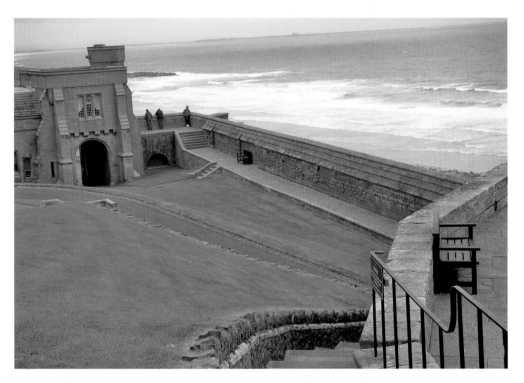

48. The West/East Ward wall reaches the sea wall, where the dominant material is a red sandstone. The arch leads to the West Ward.

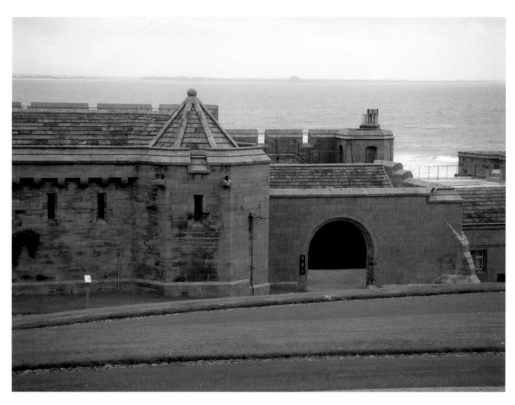

49. From this dividing wall, with some of its attached buildings including a modern toilet block and stables, Holy Island castle can be seen rising from the island on the horizon.

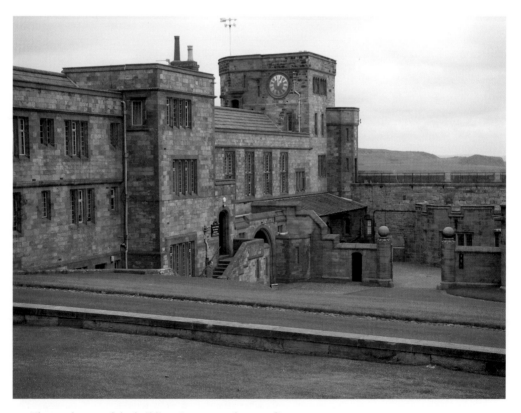

50. The south part of the buildings is now used as a café.

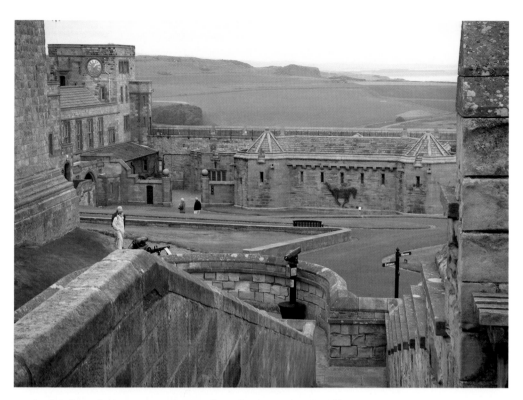

51. A view from the keep across the Wards to the distant basalt cliffs.

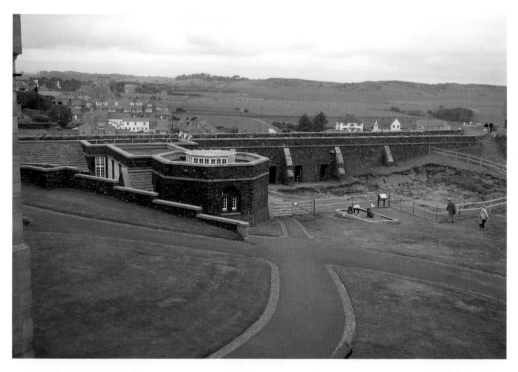

52. The West Ward includes the Museum building and the site of excavations where early Anglian finds have been made. The excavation programme has now unearthed artefacts from the Neolithic and, in the dunes themselves, a large Anglo-Saxon cemetery has been rediscovered. The Museum here displays work of Lord Armstrong, and the recent finds are in the keep. There is a small sand pit on site where youngsters can make their own 'discoveries'.

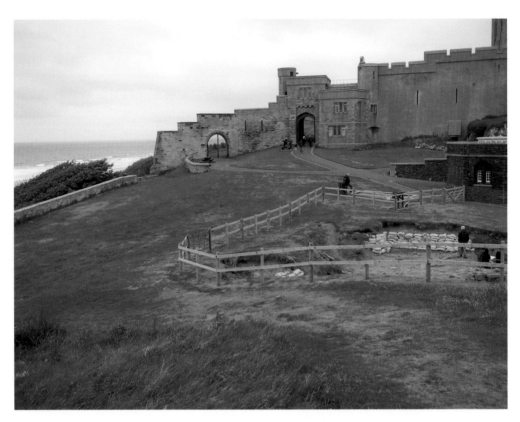

53. The museum is built of black basalt. To the right are the headquarters of the archaeologists.

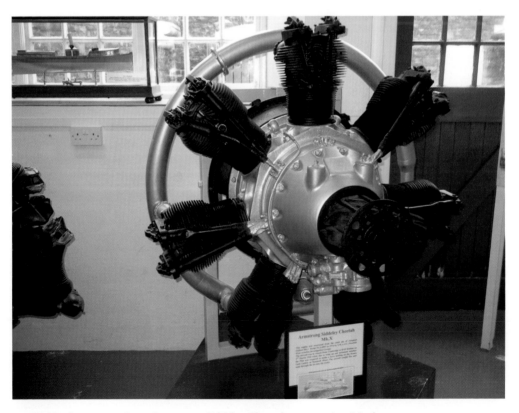

54. Within the museum is an Armstrong Siddeley Cheetah aero engine, Mark 10.

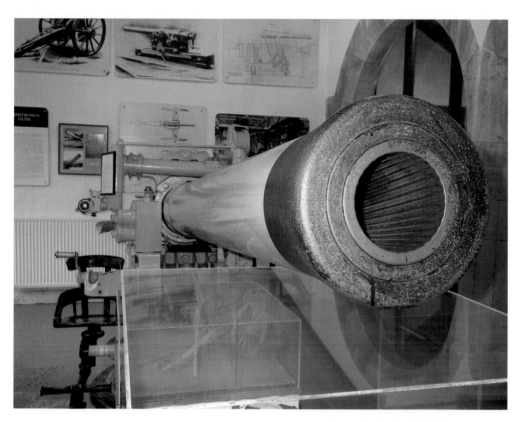

55. The breach-loading guns that Armstrong developed changed the nature of modern warfare.

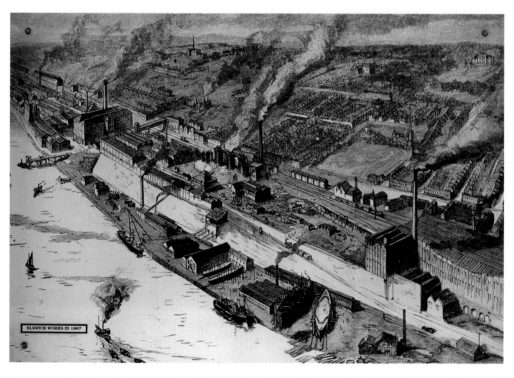

56. A display board in the museum shows the Elswick works on the Tyne in 1887, which allowed all this industrial development for use in both peace and war, and enabled Lord Armstrong to build Cragside, near Rothbury, and to renovate Bamburgh from the profits.

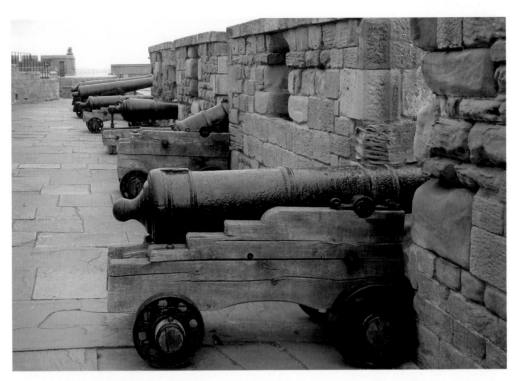

57. Older muzzle-loading guns which children love to sit on along the sea-facing wall from another age remind us how far the industrial North-East developed more lethal armaments.

58. Away from the castle and its turbulent history, the natural limestone pavements that break through the sand provide a quiet and generally human-free place to walk in peace.

The village is detached from the castle, as geology dictates, over a flat area, now a cricket ground. There is little left that is old, but the central area is like a village green where roads come in, and there are signs of an abandoned village to the south behind the present houses. The church is the oldest survival of this settlement, and Bamburgh Hall incorporates medieval masonry. There was an Augustinian cell and a Dominican Friary, the latter at what is now called Friary Farm.

DUNSTANBURGH CASTLE

This section begins with some photographs of Dunstanburgh taken from the air, beginning far out, gradually homing in on the castle.

1. From the far north, the width of the coastal plain and its large arable fields dominate the scene, with the coast showing the thin sandy beach at Embleton Bay leading to the basalt peninsula on which the castle is built.

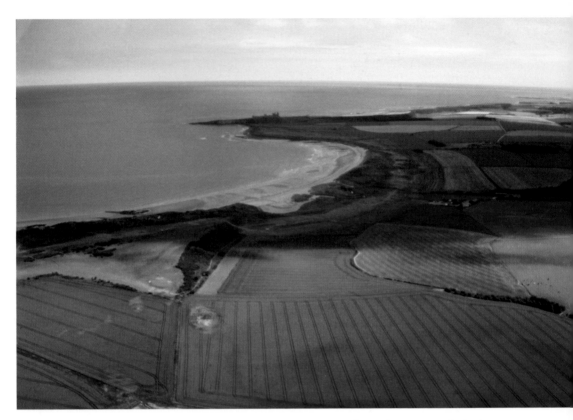

2. Further south, the peninsula is filmed closer, with the little fishing village of Craster on the horizon.

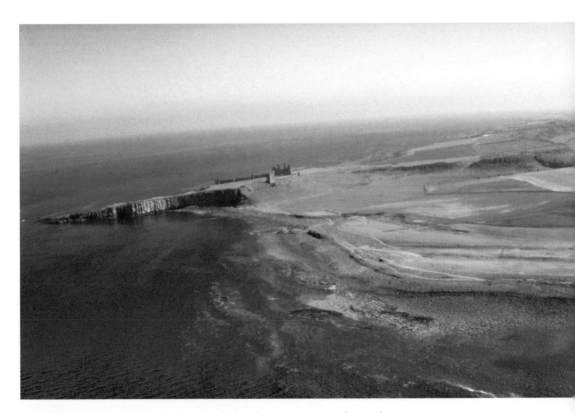

3. Embleton Bay, lower right, leads on to the basalt promontory to the south.

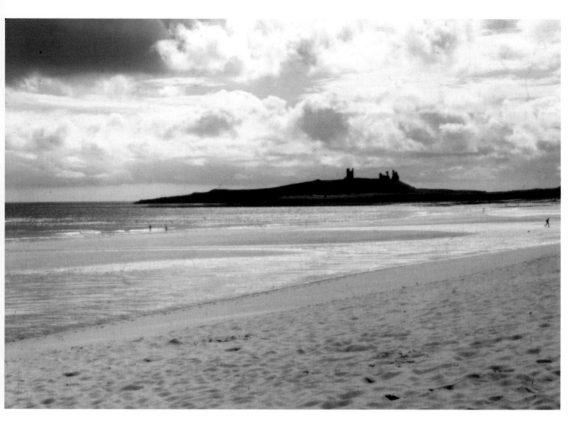

4. The castle, south from the sandy beach.

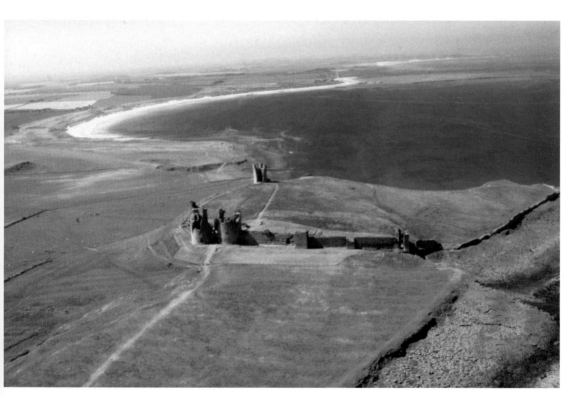

5. The castle from the south on the path from Craster, with the curve of Embleton Bay to the north, and the parallel rig and furrow running across the picture.

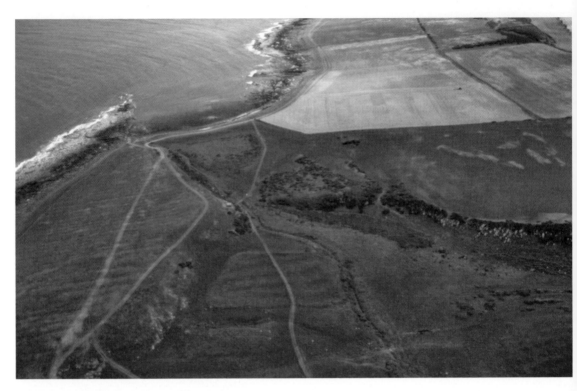

6. Further south, the path leads to Craster.

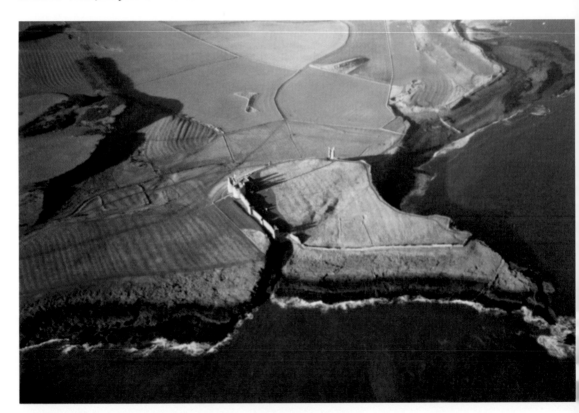

7. From the sea, the whole of the peninsula is in the picture, including the inlet through the basalt cliffs. The castle wall and towers are well defined, and the rig and furrow picked up perfectly. At the top of the picture, the golf course makes use of some of the land. (*Marian Clark*)

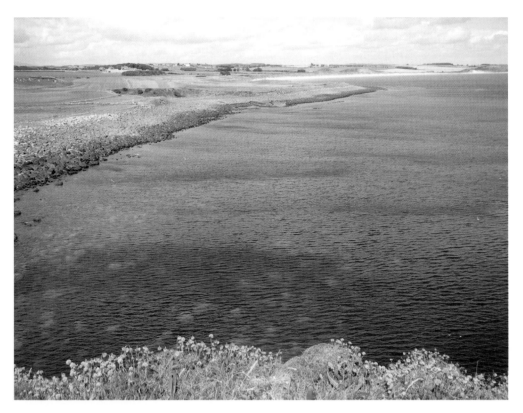

8. From the cliffs, we see the sweep of Embleton Bay to the north.

9. The basic rock structure of the coast is seen in this anticline, where the layers of sedimentary rocks are folded and dip under the sea.

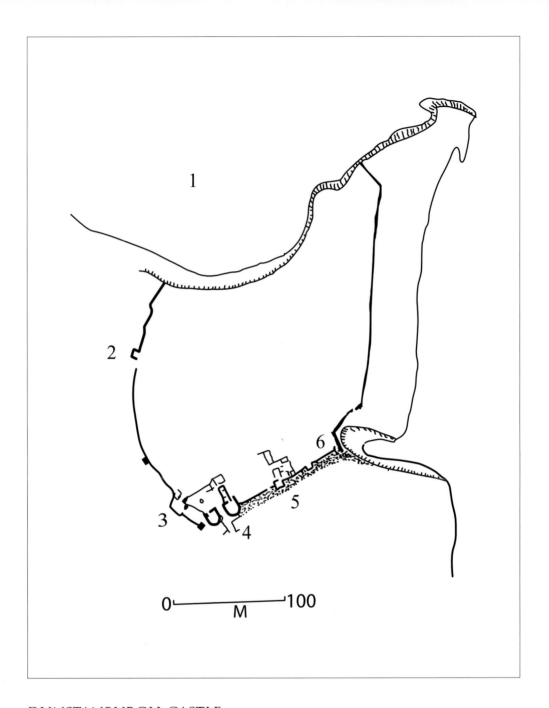

DUNSTANBURGH CASTLE

1. Embleton bay
2. Lilburn Tower and Postern
3. John of Gaunt's gatehouse
4. Gatehouse and Keep
5. Constable's Tower
6. Egyncleugh Tower and gateway

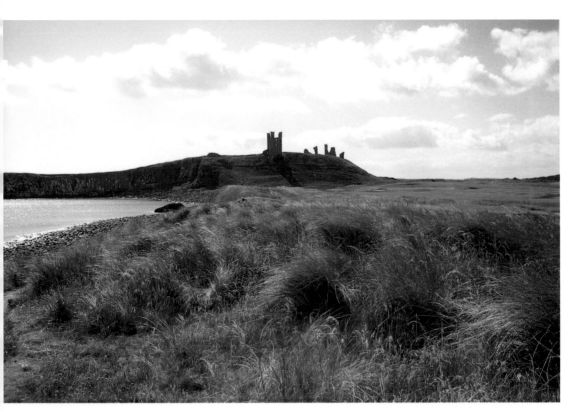

10. The castle is approached from the north along dunes that are held together with marram grass.

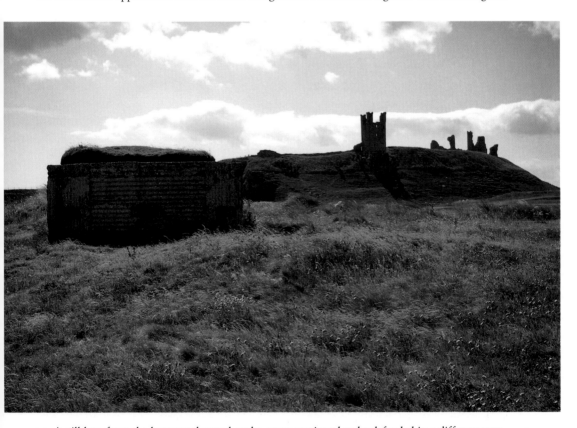

11. A pill box from the last war shows that the coast continued to be defended in a different way.

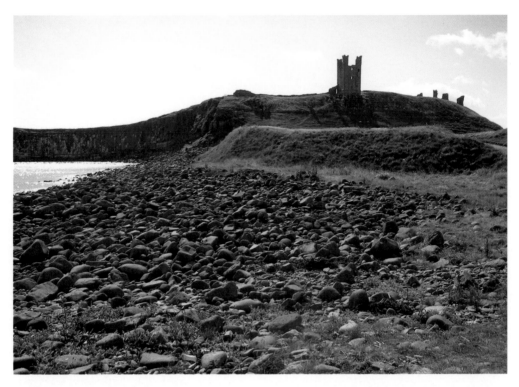

12. The beach is strewn with packed, rounded, water-eroded boulders. In historic times the castle harbour became blocked by them.

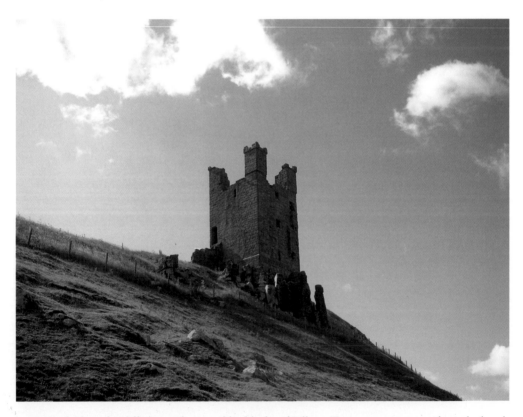

13. As we look to the cliff, the sandstone ashlar blocks of Lilburn Tower seems to grow from the basalt pillars.

Right: 14. The pillars form curious shapes that resemble thick-lipped statues on Easter Island.

Below: 15. Further south there is a side entrance to the castle, built by John of Gaunt, below the western wall.

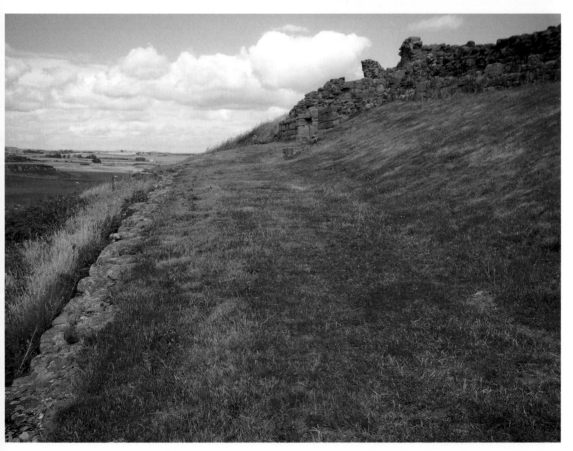

16. This entrance to the castle, which replaced one through the southern drum-towers, has its own small barbican, forcing the attackers to approach at a difficult angle along a narrow road.

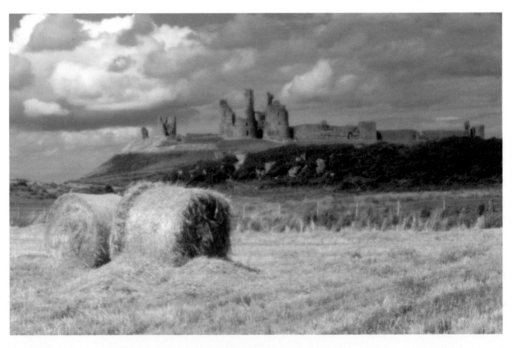

17. From the south, there is a gentle slope to what was at first the main gateway, originally separated from it by a moat, now partly filled in. The gateway serves as the castle keep, a front-line defence and residence, the towers of which are built of sandstone that erodes into holes. Here we see it from the approach from Craster.

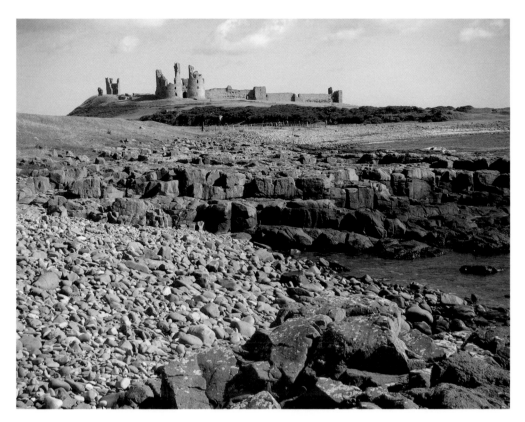

18. From the south, the beach is rocky and boulder-strewn. On the horizon the length of the south curtain wall and its turning to the north from the south-west corner can be seen.

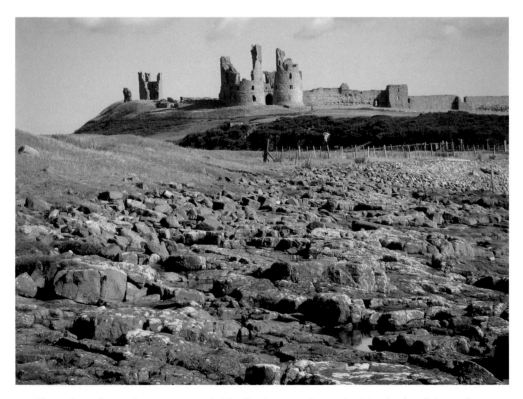

19. Closer, from the south-west, a natural ridge lies between the gently rising land and the castle.

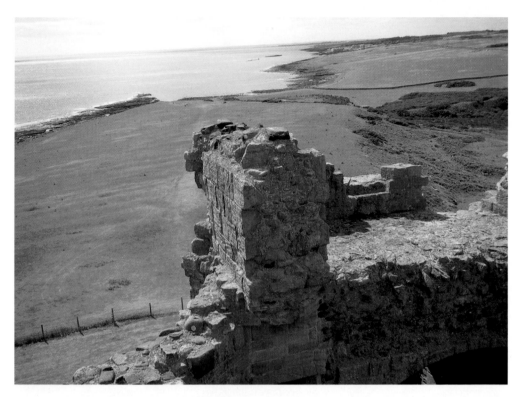

20. From the top of the keep we see the approach to the castle from the south, with Craster in the distance.

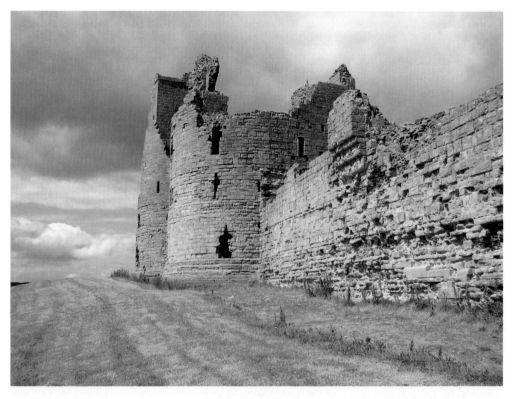

21. The south curtain wall, seen from the east, leads to the drum towers of the keep, with a moat in front.

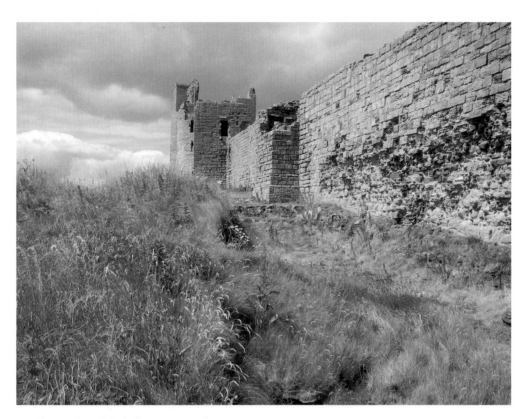

22. The south wall includes a turret and tower.

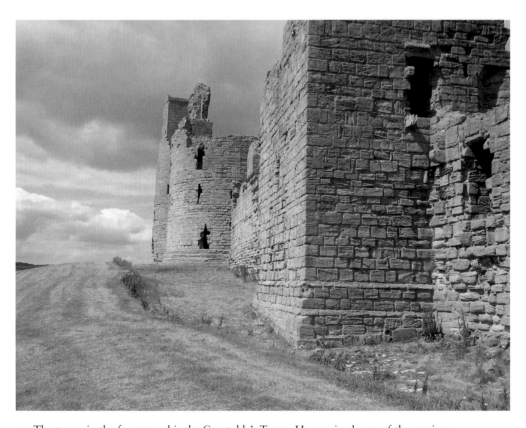

23. The tower in the foreground is the Constable's Tower. He was in charge of the garrison.

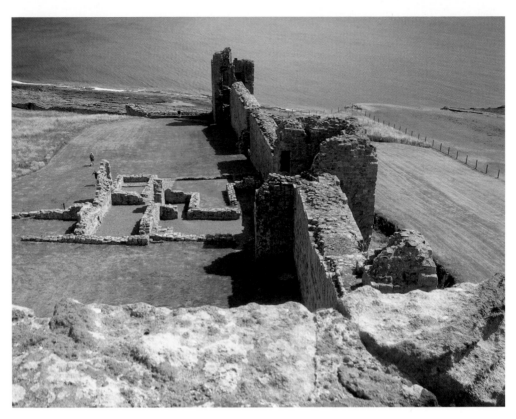

24. From the top of the keep we look eastward along the south curtain wall to the sea.

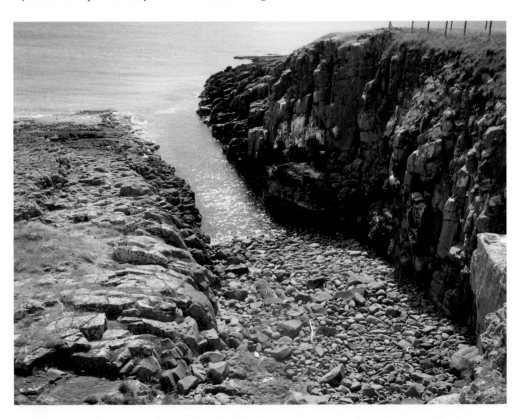

25. There is an inlet splitting the steep basalt cliffs that are the nesting place of many sea birds.

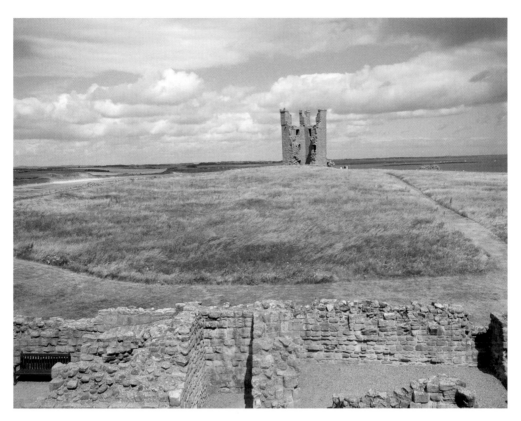

26. The interior of the castle enclosure is an open space, seen here from the keep to the Lilburn tower, north.

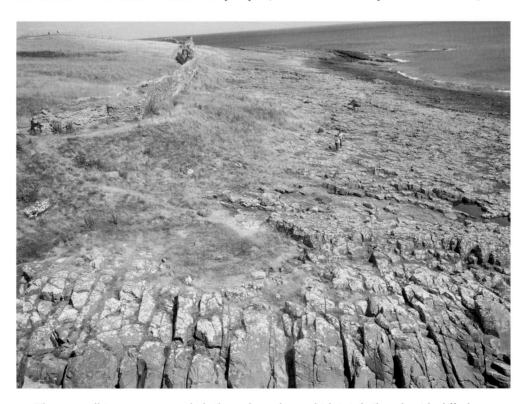

27. The east wall is not very strongly built, as the rock on which it is built ends with cliffs that are a natural defence.

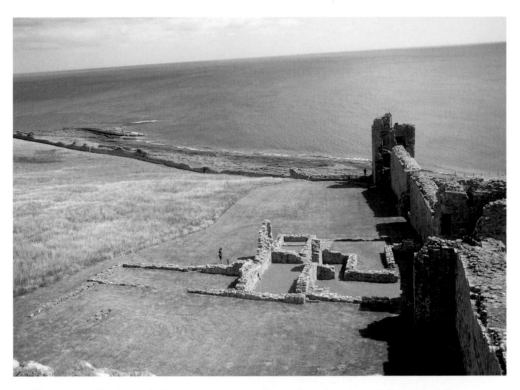

28. The space within the castle interior is seen again here, where the east wall lies at the edge.

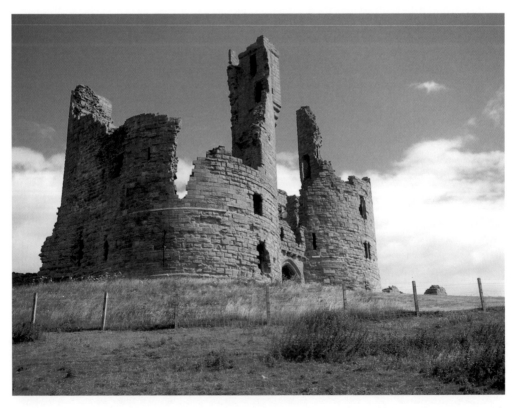

29. The original strong point of the castle and its imposing entrance is formed by two drum towers with an arch between them. This was, for visitors by land and sea, a reminder of the power of its occupant. Here the keep is seen from the south-west.

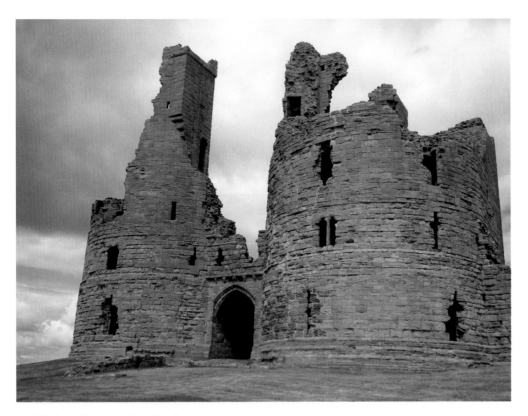

30. The keep from another direction.

31. The entrance passage is covered with a ribbed vault and there are portcullis grooves, flanked by porters' lodges with fireplaces.

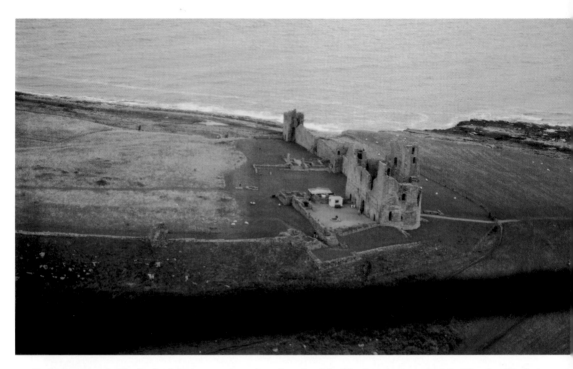

32. From the west: the flat back of the keep and south wall to the right. The interior is to the left. (*Gordon Tinsley*)

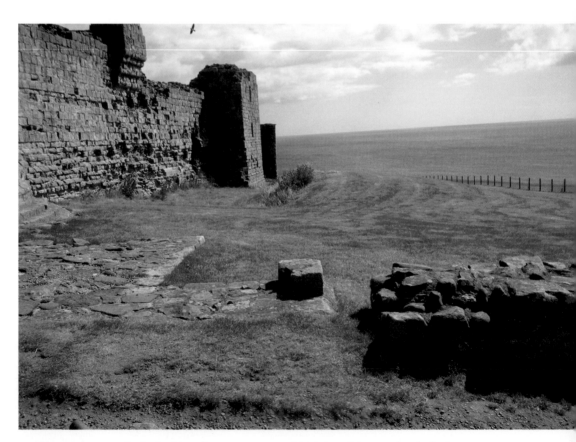

33. The entrance once had a barbican, but it was removed by John of Gaunt when he built a new entrance to the west. These walls are what remain of it.

34. The keep was three storeys high, with spiral stairs leading to turrets above the flat-backed towers. On one level above the gateway there is a portcullis slot, seen here and in the next picture.

35. The portcullis slot.

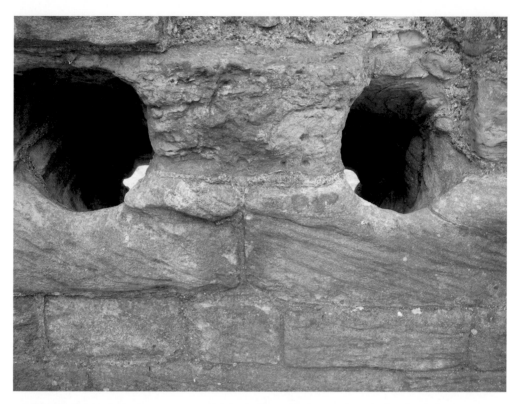

36. 'Murder holes' above the entrance enabled missiles to be showered on the heads of attackers.

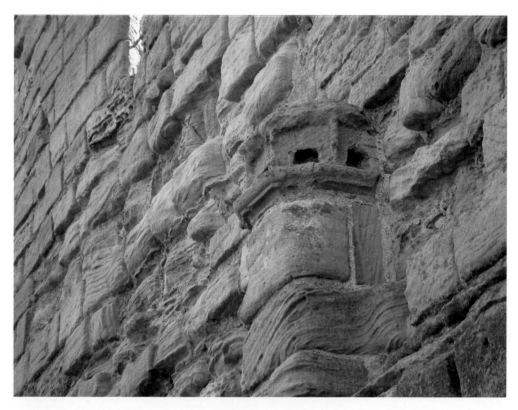

37. On the flat back of the keep are two chimneys with decorative cowls from which smoke from fireplaces inside the towers could escape.

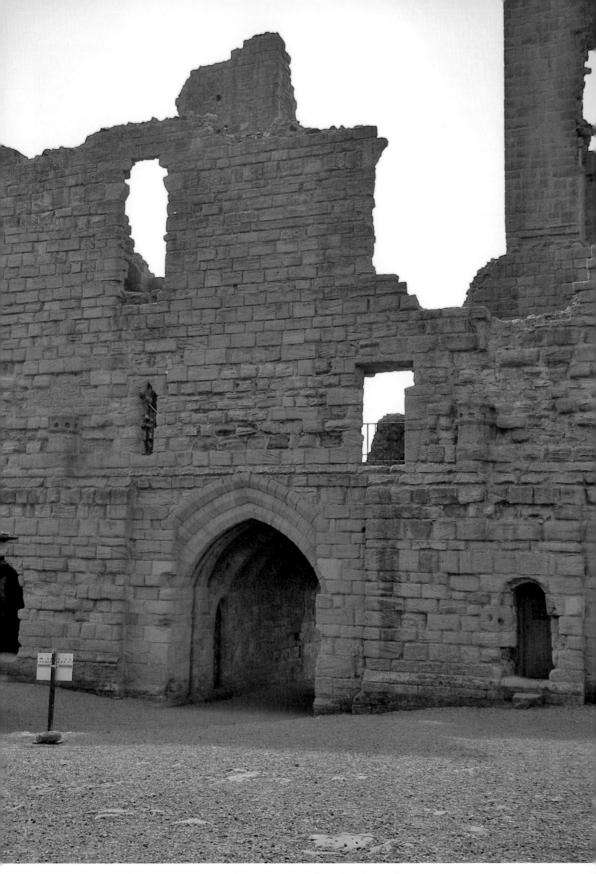

38. The rear of the keep is flat, and behind it is an enclosed yard with a well.

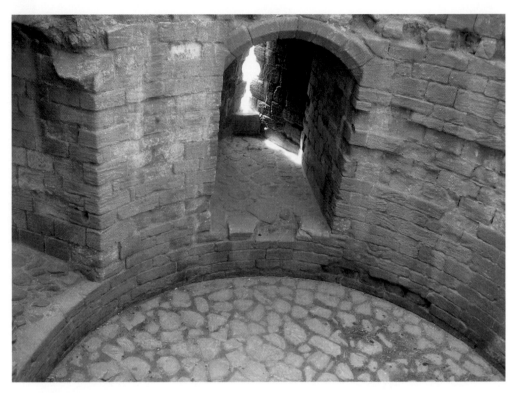

39. As befitted a castle built by one of the most powerful men in England, Thomas, second Earl of Lancaster, the interior was luxurious by the standards of the day, and a symbol of his power. The round towers above ground level have large ornate windows, and the interior shape is pleasing.

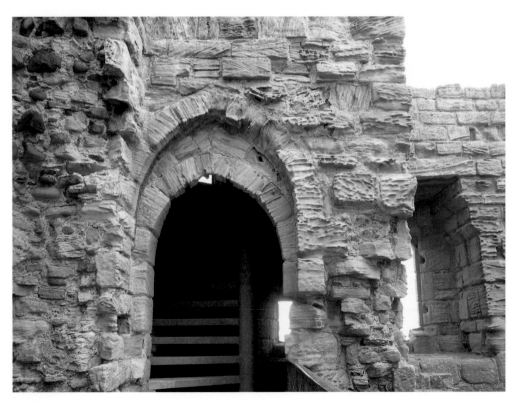

40. The three storeys are reached by spiral stairs, with the entrance to one at the east end seen here.

41. Covering the head of the stair was this umbrella-like canopy; though ruined, its form is still clear.

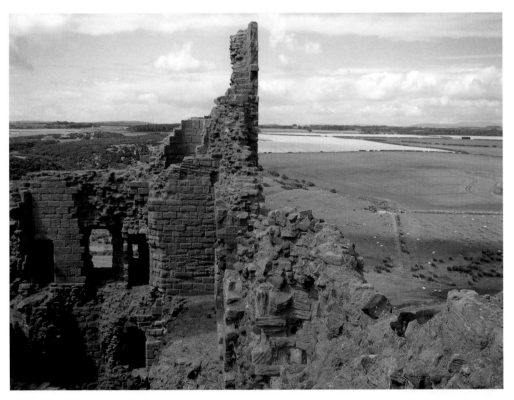

42. To the west is one of the turrets that rose high above the landscape, giving excellent all-round views. Lofty, square turrets above the spiral stairs were built at the north-east and north-west corners of the keep, with the north-east stair still accessible by the public.

43. A floor ran from east to west, used for a Great Hall and kitchen on the second floor, with stairs to both; there were private family rooms above that.

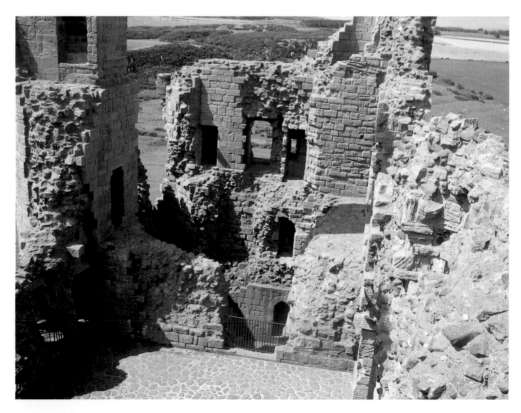

44. At a high level, we look down on the western interior.

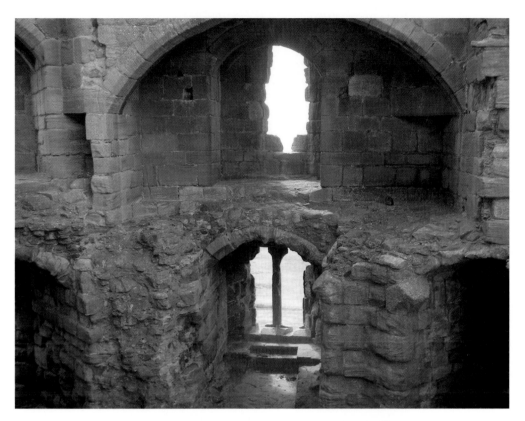

45. The keep windows, facing south, give some idea of the quality of the building.

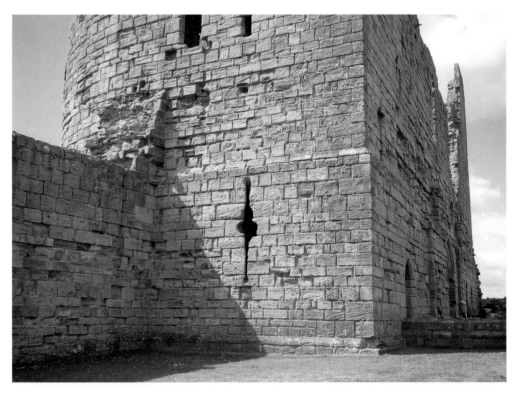

46. The keep inside the south wall, seen from the north-east, has very fine masonry, well bonded, and shows a change from large to small blocks of stone from Early English to Decorated style.

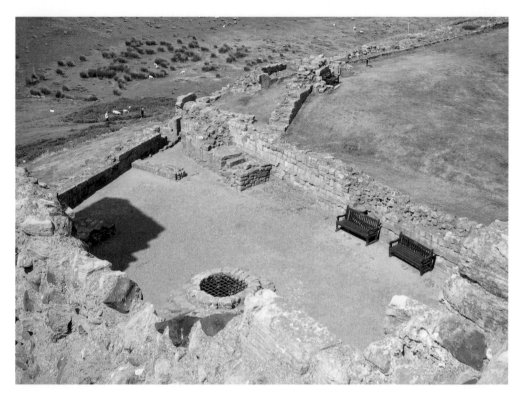

47. The towers give access to the Inner Ward – a small yard with a well, flanked by a tower and walls with access through the late fourteenth-century barbican running to the north of it. It was built after the gatehouse was blocked.

48. Here is John of Gaunt's gate to the west, giving access to the keep from behind.

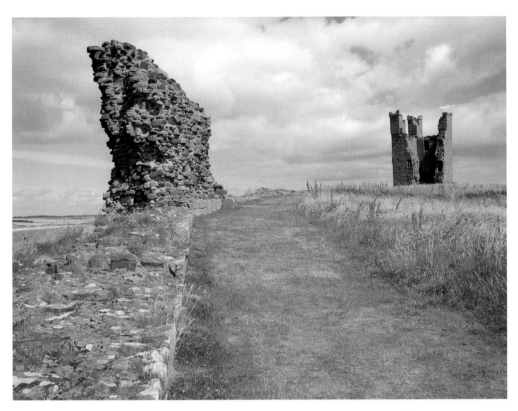

49. From the north-west corner of this Ward ran the curtain wall, leading to the Lilburn Tower, a square turret, built about 1325.

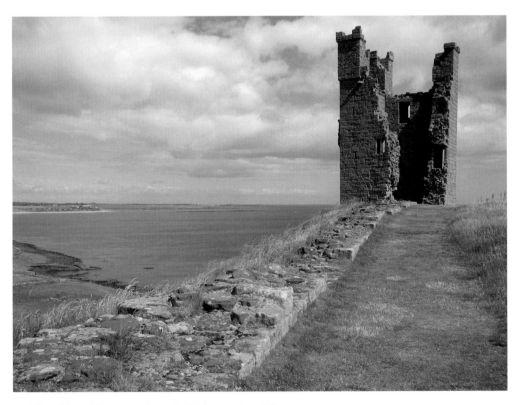

50. The Lilburn Tower stands at the highest point of the site.

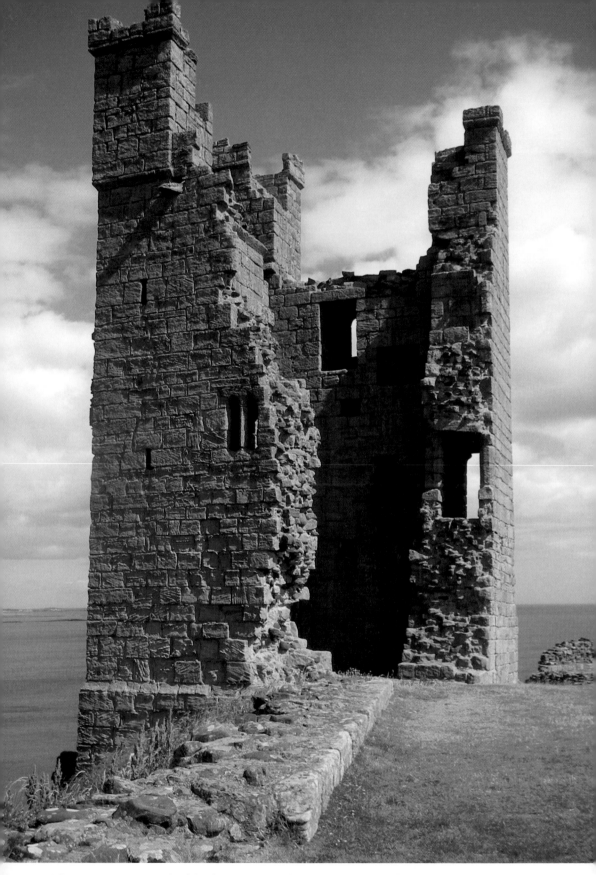

51. There was a room in each of the three storeys, with turrets on top at each corner, joined by a parapet.

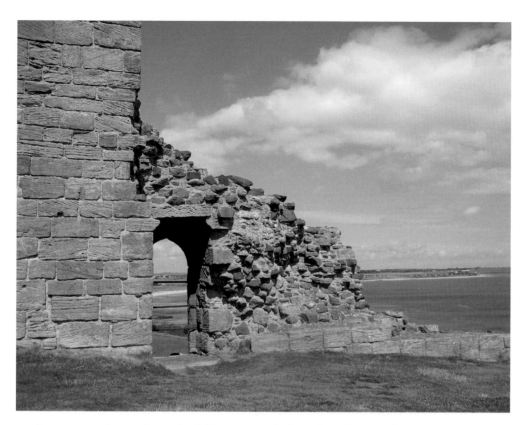

52. A postern gate just to the north of this tower was built at about the same time.

53. The wall ends at Gull Crag, a precipice.

54. We cross the open space to the east wall, poorly constructed in sections, which runs almost straight to Egyn Cleugh. We see it here from the top of the keep, looking north-east.

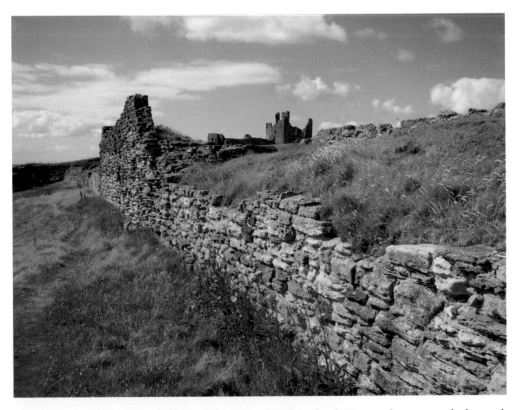

55. A postern survives in the wall just before it reaches Egyncleugh Tower, where we reach the south curtain wall.

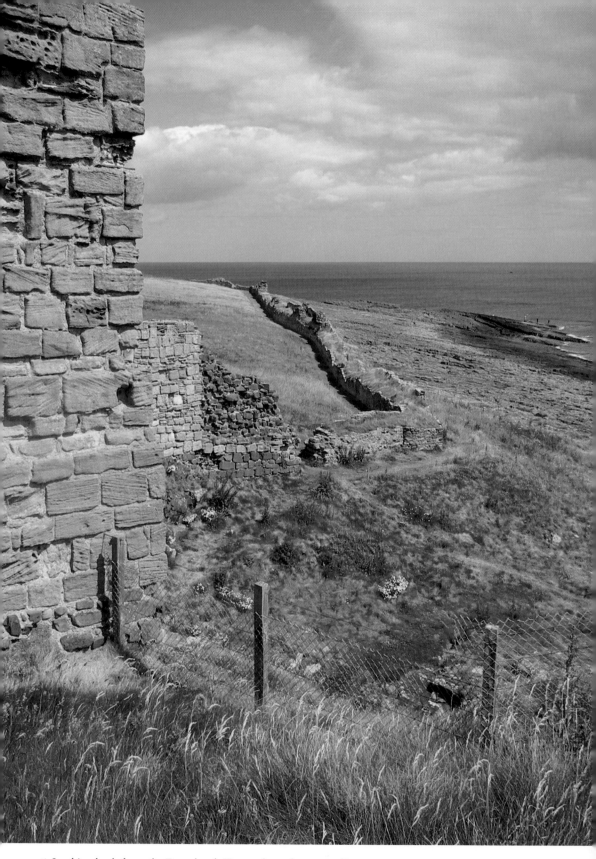

56. Looking back from the Egyncleugh Tower along the east wall.

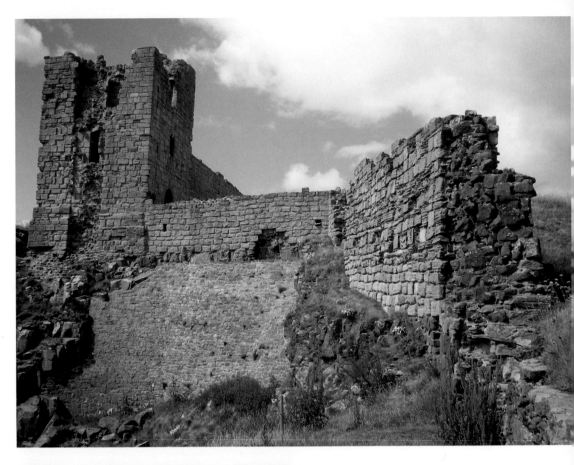

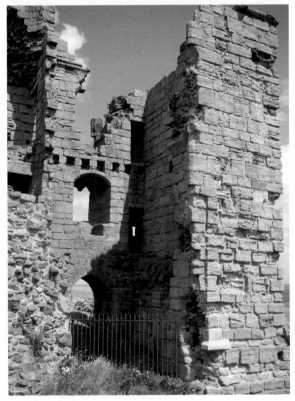

Above: 57. The Egyncleugh Tower has been bolstered up on the inlet side in modern times, as we see from the east.

Left: 58. The Egyncleugh Tower, with gateways to the north and south, is square, with a barrel vault of massive stones. From it, a spiral stair led up to the parapet wall.

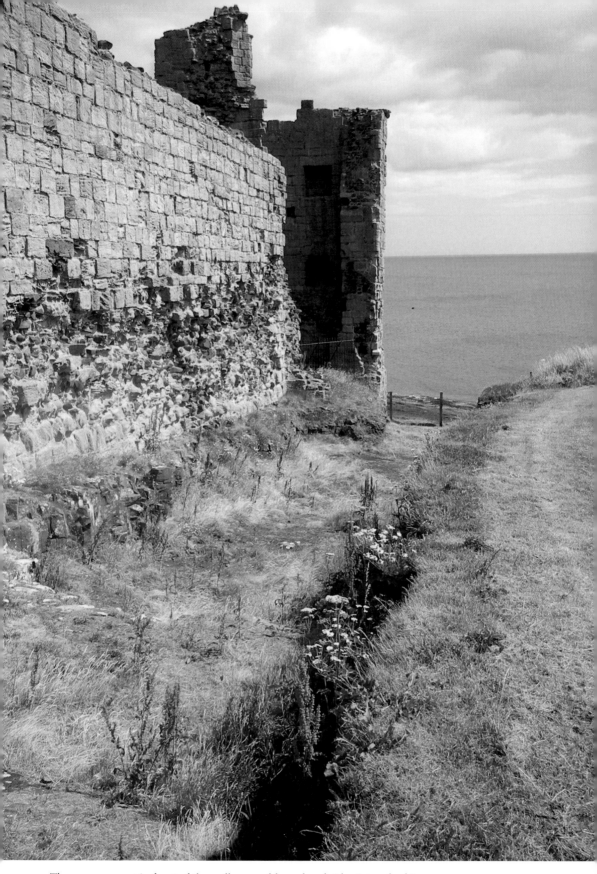

59. There was a moat in front of the wall, crossed by a drawbridge into a barbican.

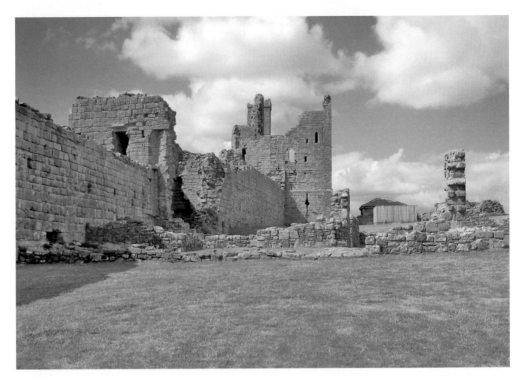

60. The next addition to the wall westward is a turret, then the Constable's Tower, housing the man in charge of the garrison. It lies across the wall north to south, is two storeys high, and has a spiral stair in the north-east corner. We see it from inside the curtain wall. Behind the Constable's Tower, projecting from the Inner Ward, are other buildings, but the remains are slight.

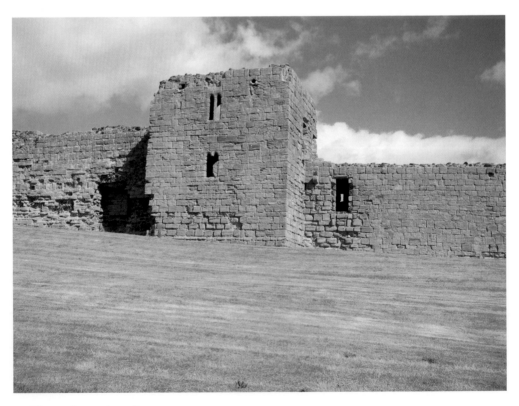

61. The south curtain wall.

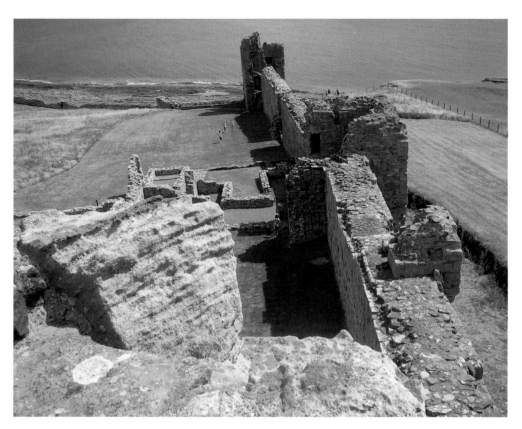

62. From the keep we see over the Constable's Tower to the Egyncleugh Tower.

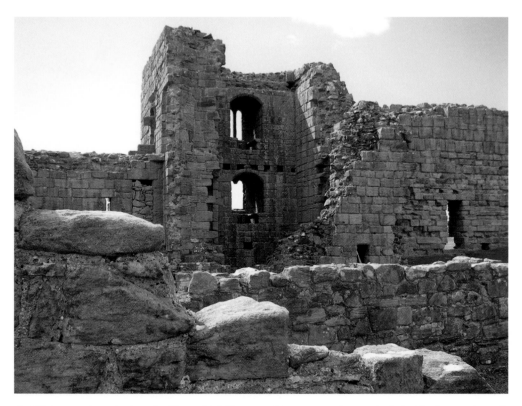

63. We have a closer look at the Constable's Tower and its annexes that are built inside the curtain wall.

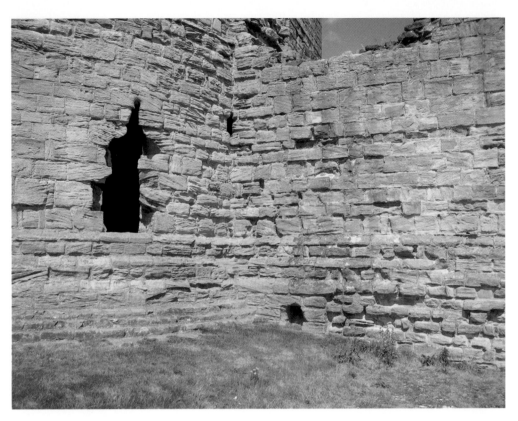

64. The curtain wall to the keep has the best masonry, with nine courses bonded to it.

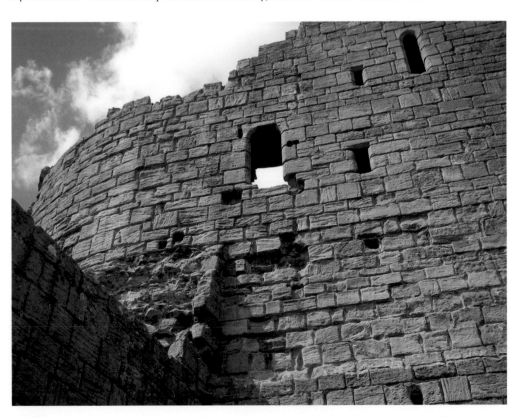

65. The keep masonry seen from inside the enclosure, with the position of the parapet wall.

66. The castle had its own harbour that was reached from the sea through a great ditch dug in 1314, leading round the castle site to Embleton Bay, making the castle an island. The harbour became blocked with shingle.

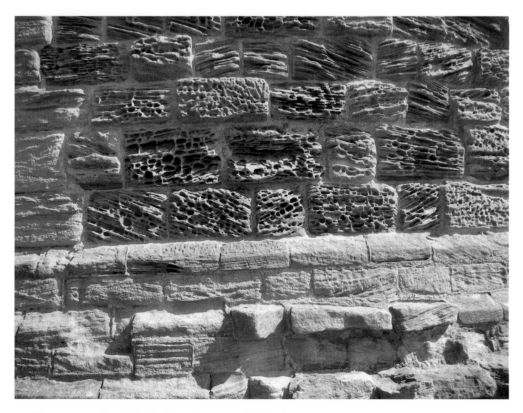

67. The stone used to build the keep is very eroded in places.

68. Here we see the south wall built on solid basalt, with the ditch in front.

ALNWICK CASTLE

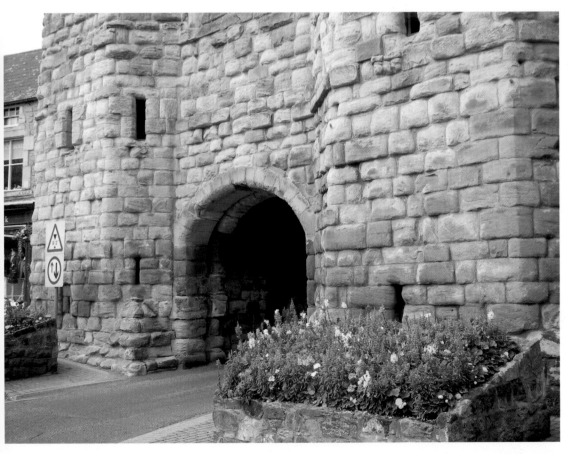

1. The Hotspur Gate is an entrance through the wall that used to encircle the town situated outside the castle. Licence to fortify the town was given in the early fifteenth century.

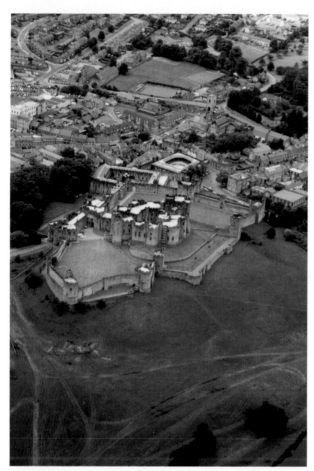

Left: 2a. The castle was built above the river valley, giving it a natural defence to the north and east; the south had the Bow Burn as another steep natural defence. The town is in the top part of the picture. The point of the triangle of castle walls is the Record Tower, with walls encircling the whole site via a number of square and circular towers. At the centre is a moated keep. At the top are Stable Court and Riding School, both additions made by the architect Salvin. The Bow Burn skirts the castle to the left. (*Gordon Tinsley*)

Below: 2b. A second view is from the north-east. (*Gordon Tinsley*)

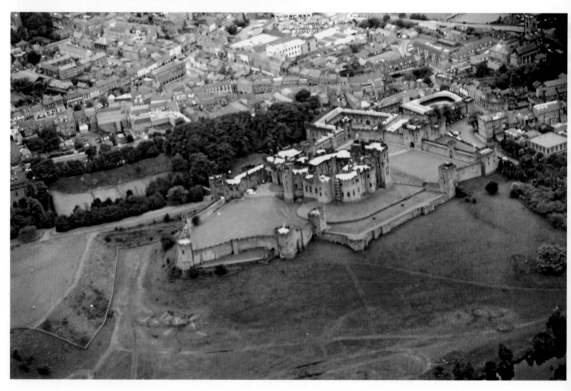

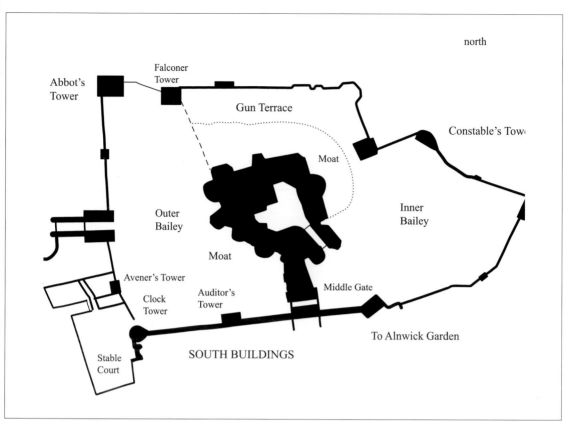

north

Abbot's Tower

Falconer Tower

Gun Terrace

Moat

Constable's Tow...

Outer Bailey

Inner Bailey

Moat

Avener's Tower

Clock Tower

Auditor's Tower

Middle Gate

To Alnwick Garden

Stable Court

SOUTH BUILDINGS

2c. A simplified sketch plan identifies features that follow as pictures.

3. Seen from the top of the Barbican Gatehouse, one road heads north towards Scotland.

4. The coastal-plain route to northern England and Scotland crosses the River Aln today over a stone bridge built by John Adam in 1773, distinguished by the 'Percy Lion' built on it.

5. Another route from the castle entrance is along Bailiffgate and past St Michael's church, seen here, and Alnwick Abbey on its way to Chillingham and Chatton.

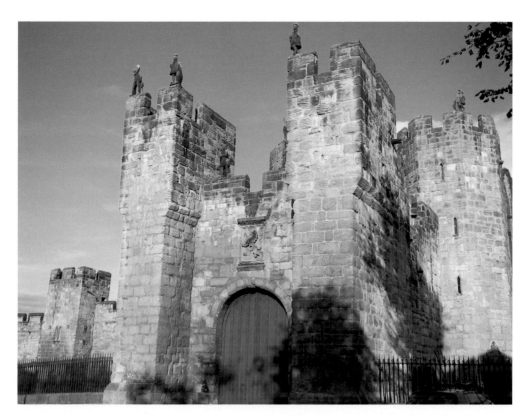

6. The entrance to the castle is very impressive. The barbican built onto the gateway is a castle in its own right, with a drawbridge that dips into the moat and presented attackers with a solid wooden wall, a portcullis, heavy doors and steep tunnel-like walls that would be a trap. The decorative statues on it are mostly copies of earlier ones.

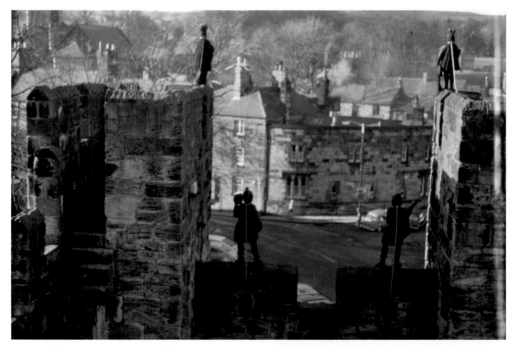

7. The view north-west from the gatehouse down Bailiffgate, a large open area where troops could have assembled.

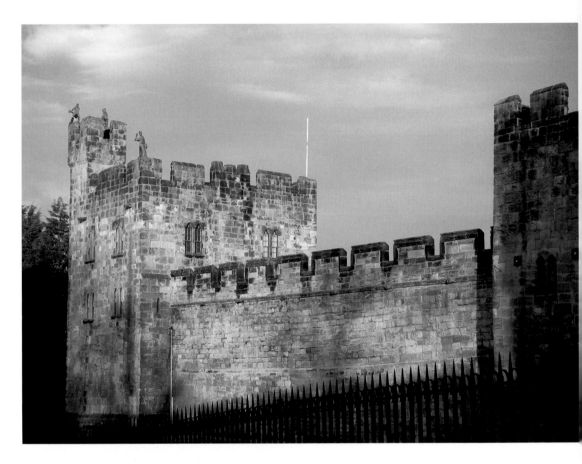

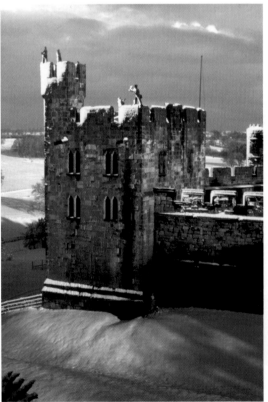

Above: 8. The original base of the curtain wall that runs around a large elongated triangle with its point at the Record Tower on the east still has some Norman masonry in places, beginning at the left of the Barbican, though most has been replaced or added to.

Left: 9. The wall from the gateway runs north to the Abbot's Tower, seen here from the south-west.

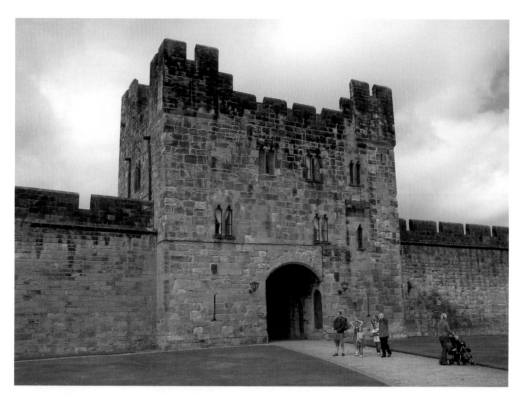

10. The gateway seen from inside the curtain walls. After the death in 1315 of the first Henry de Percy, the second Henry built the Gatehouse and Barbican, and by 1352 it had reached its present plan.

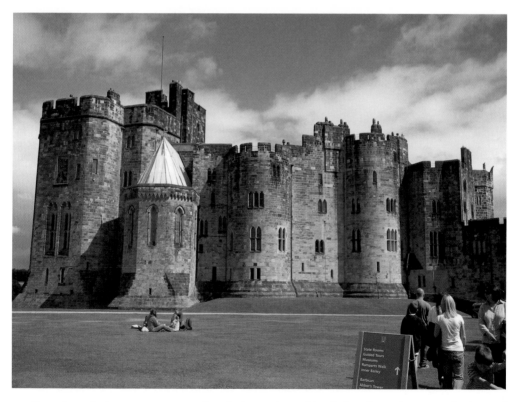

11. Once through the gateway we see that the keep takes pride of place beyond an extensive lawn of the West Bailey.

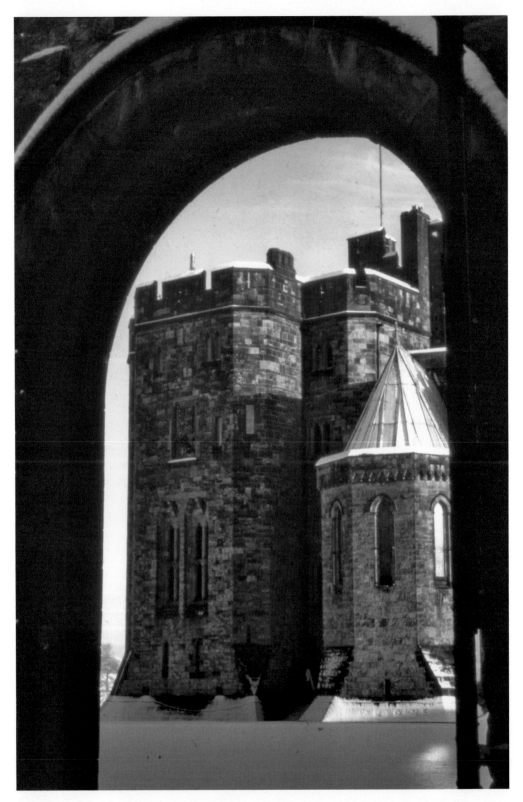

12. The keep at once announces that it is largely reconstructed on an original plan, with towers built around an inner courtyard; this was always the focal point of defence and living accommodation. We see the Prudhoe Tower and Chapel, not defensive, through the arch that leads to the Stable yard, next to the Clock Tower.

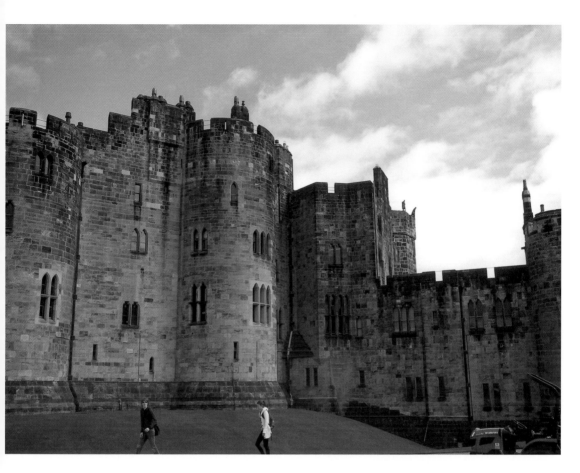

Above: 13. The denuded moat that surrounds the keep once provided the material for building the motte (mound) on which the keep stands, here curving south-east to meet a range of buildings that give access to the keep from the south.

Right: 14. The chapel is in the foreground, with rounded towers beyond, and the moat to the right.

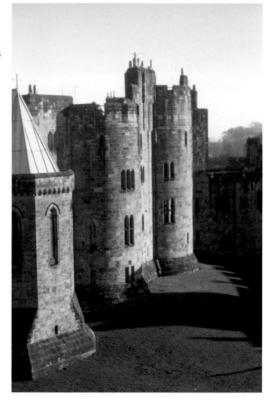

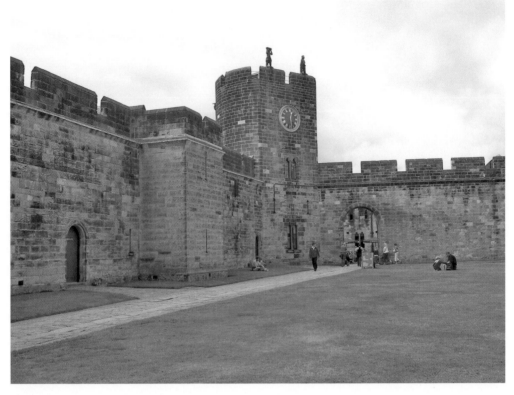

15. The south curtain wall of the West Bailey includes the Clock Tower in the south corner, with a medieval plinth.

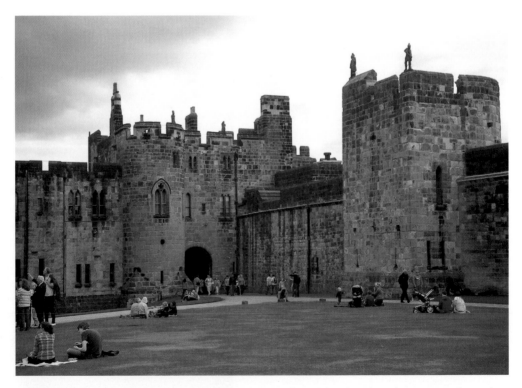

16. The Auditor's Tower, further east along the curtain wall, is old and D-shaped, now part of a modern corridor used by the estate office.

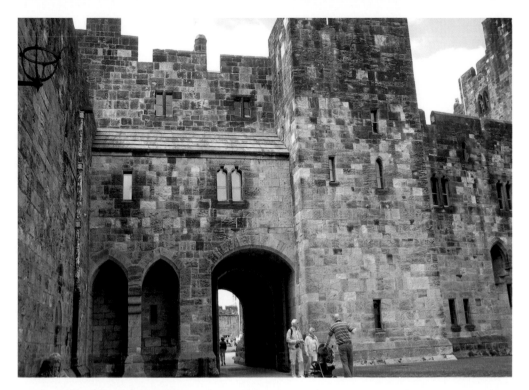

17. The wall east reaches the archway of the Middle Gate, where another range of more recent buildings crosses into the keep to the north.

This north to south range into the keep is part of the 'Baronial Gothic' built by Anthony Salvin, where food was prepared, wheeled through a tunnel, and taken up by a lift. The building was utilised by the College of Education until 1977, and after that by St Cloud University.

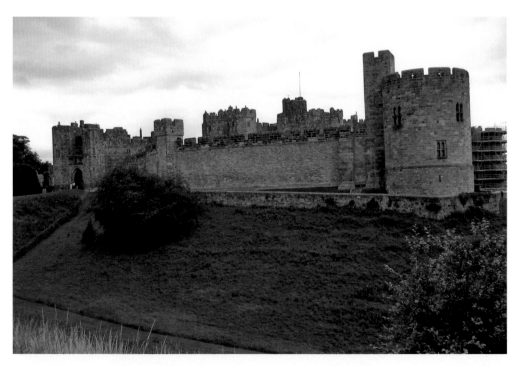

18. Beyond this, the other way into the keep runs from what is Salvin's Garden Gate, which has a brewhouse and icehouse under it.

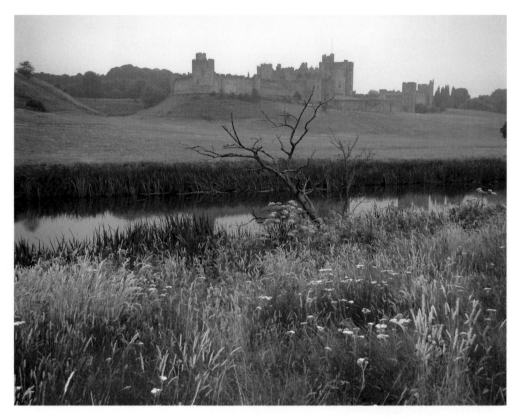

19. The south wall further east is bounded by a steep natural drop, seen here from the river.

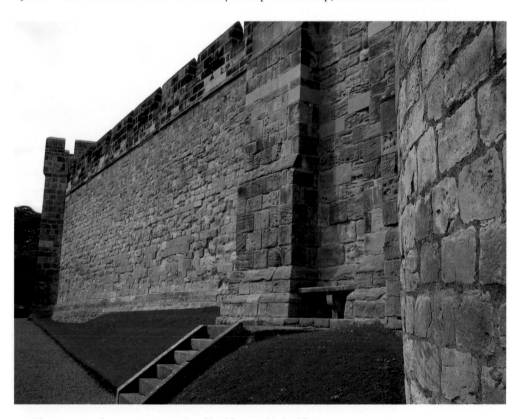

20. The masonry shows many periods of building and rebuilding.

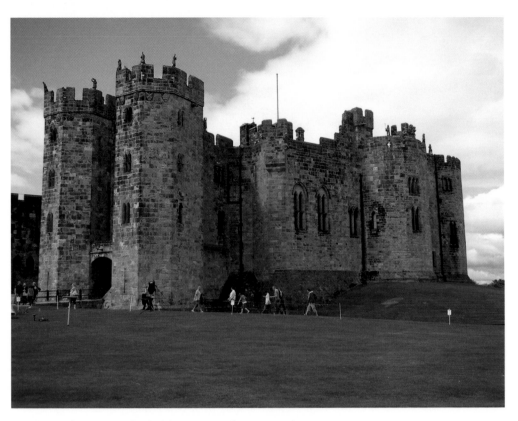

21. The keep gateway is flanked by semi-circular octagonal turrets.

22. At the top of the towers are shields displaying the pedigree of the owners and their alliances. Included prominently is the Percy lion.

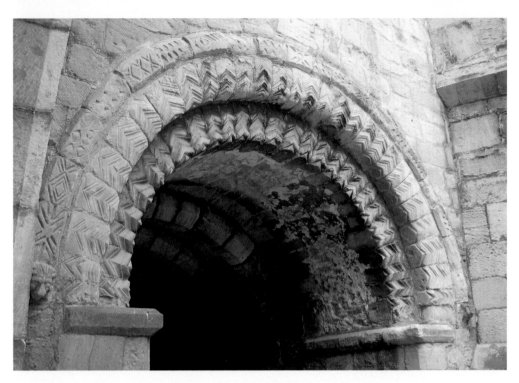

23. The gate passage-vault is ribbed, showing different periods; then we encounter an early twelfth-century decorated arch into the centre of the keep – the Inner Court that has been considerably rebuilt, mostly *c.* 1854.

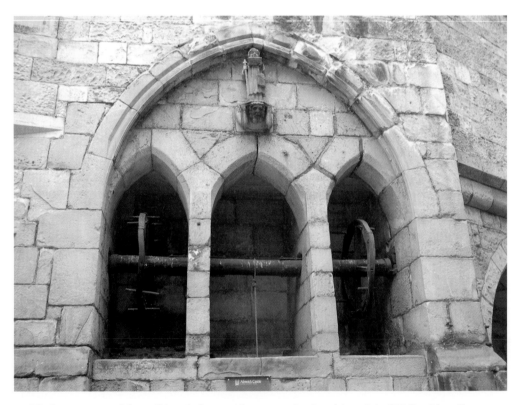

24. The lower course of the wall here is fourteenth-century, the site of the original Hall, with well recesses.

25. Towers and rooms encircle the centre of the keep; most of what we see was the work of Salvin, who employed Italian craftsmen to do the interior decoration. The original semi-circular towers had been added in 1309 when Henry de Percy owned it. This is the Inner court.

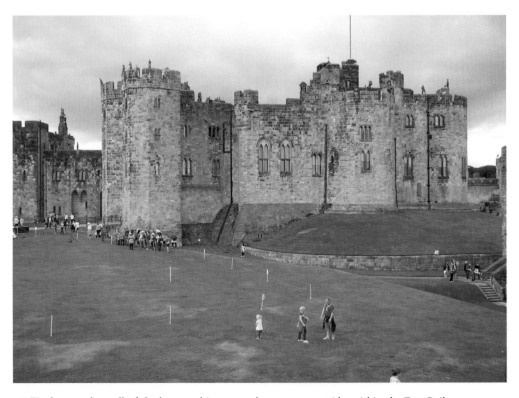

26. To the east the wall of the keep and its towers has a moat outside, within the East Bailey.

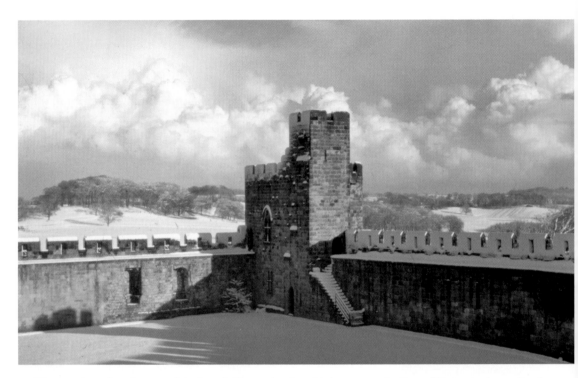

27. The curtain wall to the east of the keep is like a triangle, with its apex at the Record Tower in the medieval wall, once open-backed, rebuilt above its base in 1880.

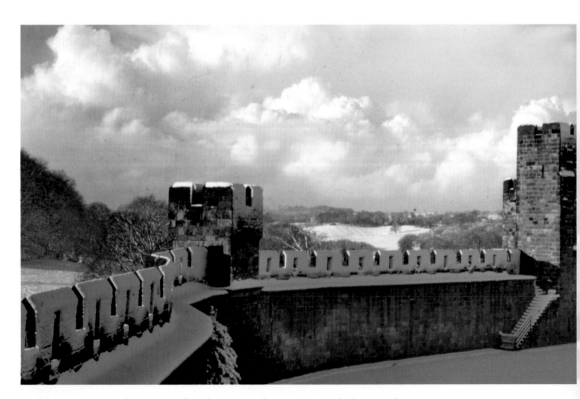

28. The next feature along this wall and its restored parapet is a rebuilt garret known as Hotspur's Seat.

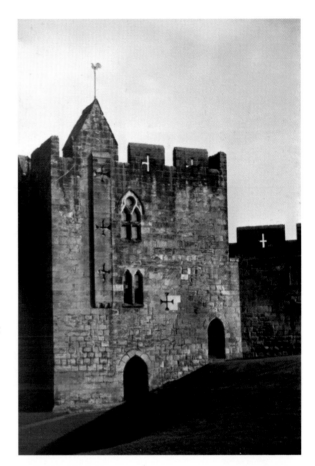

Right: 29. The Constable's Tower, named after the man who was in charge of the castle, is apsidal on the outside and flat on the inside, where fourteenth-century features are clear.

Below: 30. The curtain wall has some twelfth-century stone in place, especially between the Constable's Tower and the next – the Postern Tower.

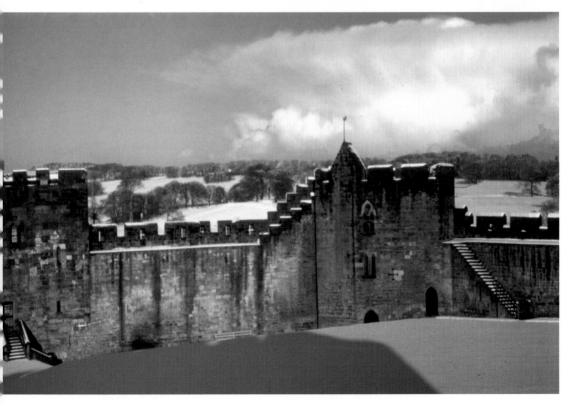

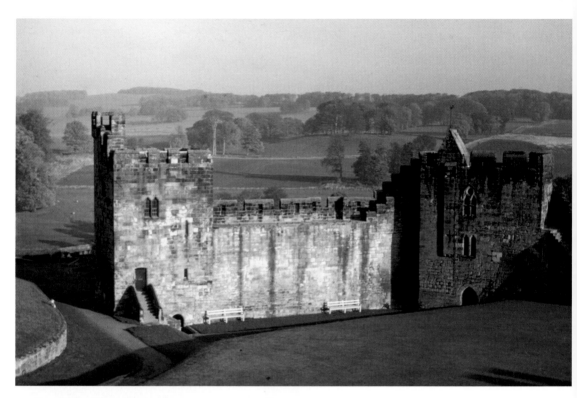

31. The Postern Tower has become an important museum, with a fine collection, especially of local prehistoric material, open to public display. It is reached by a narrow internal staircase.

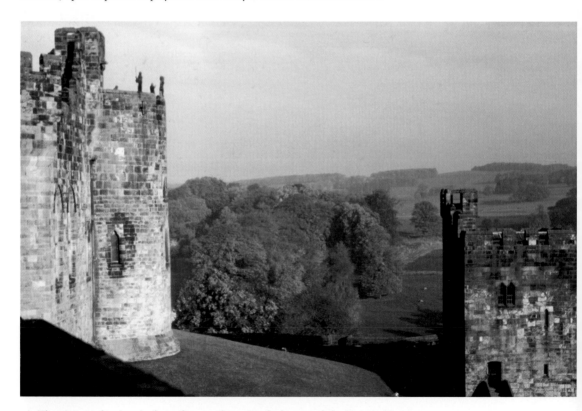

32. The view to the river is through a gap between the keep and the Postern Tower.

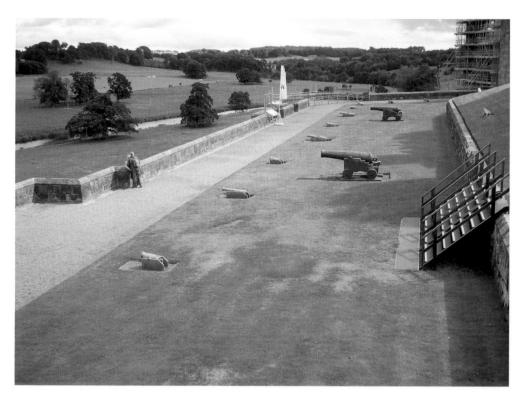

33. A Gun Terrace was added from the mid-eighteenth century onwards, facing north.

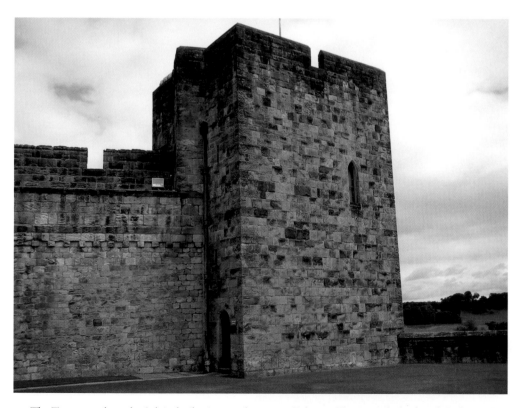

34. The Terrace ends at the Salvin-built nineteenth-century Falconer Tower, with the fourth Duke's VC in stone on its side. Originally this is the place where the medieval wall ran south-east to the keep.

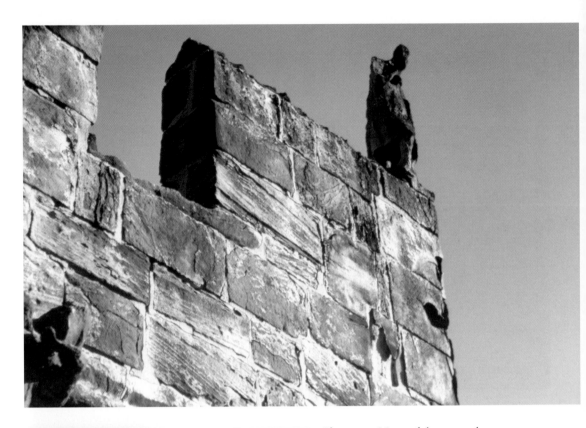

Above: 35. Many of the towers have decorative statues, some of them old and eroded like this one on the keep's octagonal tower.

Left: 36. Others are modern replacements, like this fallen statue filmed in 1974.

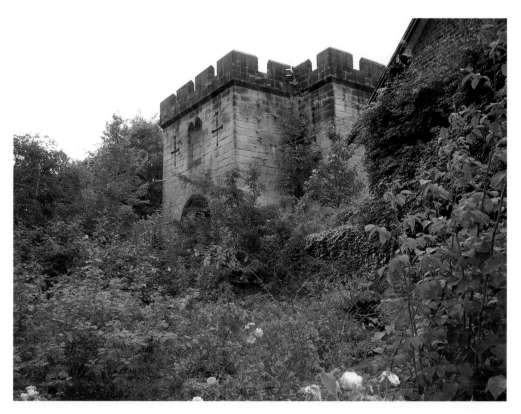

37. During the summer of 2010, when some of these pictures were taken, large crowds of adults and children spent time in the castle and its grounds, where many events such as falconry and archery took place. The Alnwick Gardens to the south have been added as an attraction, leaving original features such as this Victorian tower, and transforming the rest.

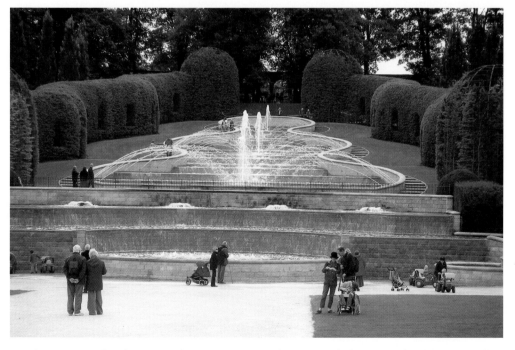

38. The Water Gardens have proved a great success, and are particularly exciting for children who love playing with water.

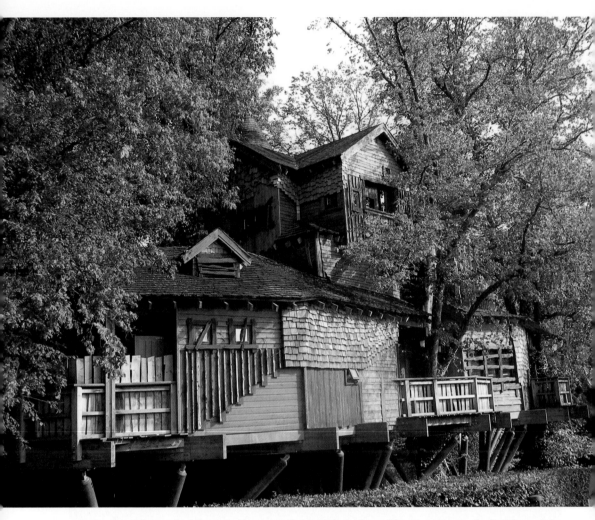

39. At a time when *The Lord of the Rings* has appealed widely to the public imagination, the building of the Tree House has been very popular. All these changes express a determination that the castle will not dwell in the past, but add something contemporary and attractive, continuing a tradition of change that we have seen in so many parts of the old castle itself. When the Percys died out, the Smithson family took over the Percy name and became Dukes of Northumberland in the eighteenth century; the first Duke got to work on what had become a ruinous castle, and so it continued to change, the main influence coming from the architect Anthony Salvin from 1854, who turned it into a residence.

Once, Alnwick had been the front line for troops while Warkworth had been the chief residence. Now Warkworth has been abandoned as a residence. Meanwhile, to visitors and film companies alike, Alnwick is what most people think of as a 'real' castle.

WARKWORTH CASTLE

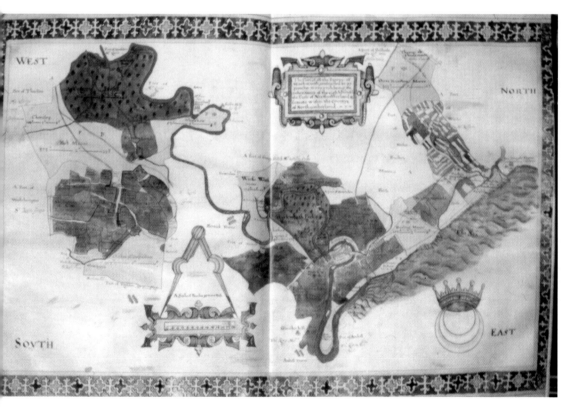

1. Warkworth is one of Britain's most beautifully-sited castles, taking advantage of a loop in the River Coquet that forms a promontory. We see in this picture of the Earl of Northumberland's estates in the 1620s a hand-painted representation of its position, and the fields and woods around it.

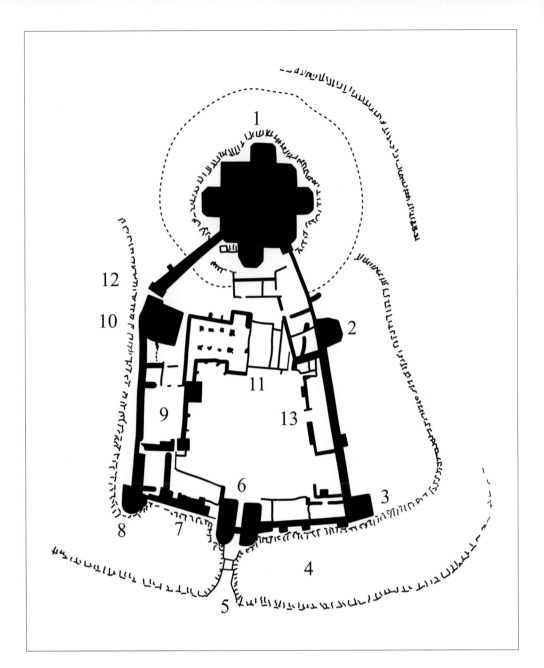

WARWORK CASTLE

1. Keep
2. Grey Mare's Tail Tower
3. Montagu Tower
4. Moat
5. Drawbridge
6. Great Gate Tower
7. Chapel and south range

8. Carrickfergus Tower
9. Great Hall and Solar
10. Kitchen
11. Church
12. West Postern Tower
13. Stable Block

Facing page: The aerial views show the relationship of the castle to its surroundings and give details of the buildings within the walls.

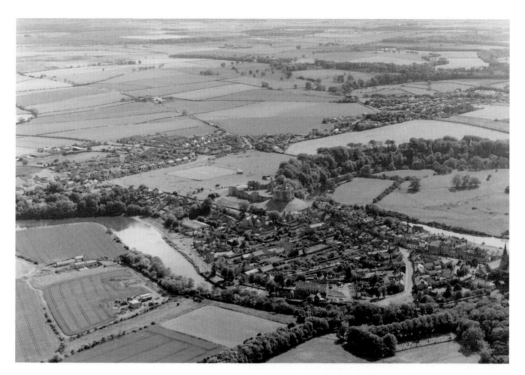

2. The castle was built as a motte-and-bailey structure at the south end of the promontory, its outer moat cutting off the area and being spanned by a drawbridge entrance leading into a heavily-fortified gatehouse. The village fills the rest of the promontory to the north. To the south are fields and the faint track of the old Green Lonnen behind the row of houses.

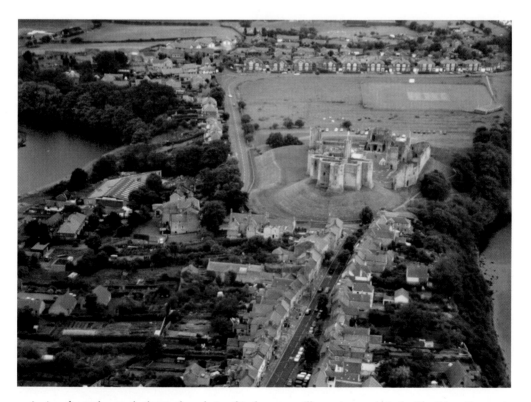

3. A view from the north shows the relationship between village, river and castle. The River Coquet is on either side of the picture, the castle central. (*Gordon Tinsley*)

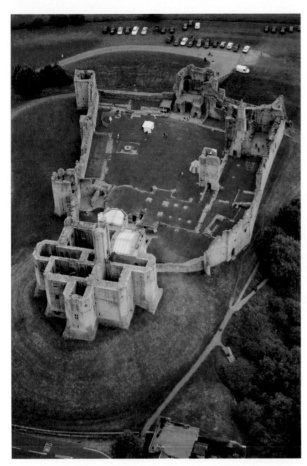

Left: 4. Norman in origin, the present keep is a later development of considerable sophistication, with elaborate windows that seem more concerned with light and comfort than defence. The centre of the keep has a shaft that allows more light in. The bailey holds the remains of a church close to the keep, with a crypt and pillar bases, but it is likely that it was not completed. Also in the bailey there is a range of buildings that includes a Great Hall with kitchens attached, a solar, a brew house, stables and many towers. From the keep, along the curtain wall from the left, the towers are: Grey Mare's Tail, Montagu, Gatehouse, Carrickfergus, and the Postern. (*Gordon Tinsley*)

Below: 5. The castle from the north-east.

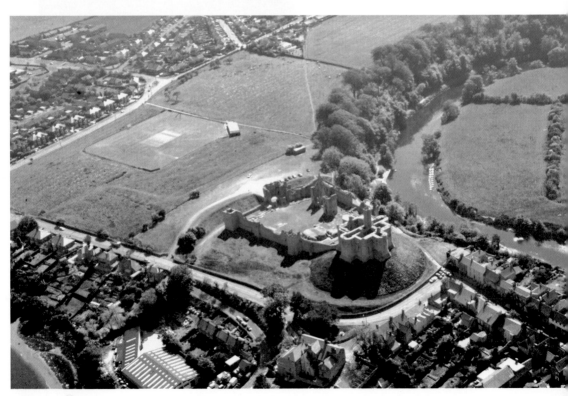

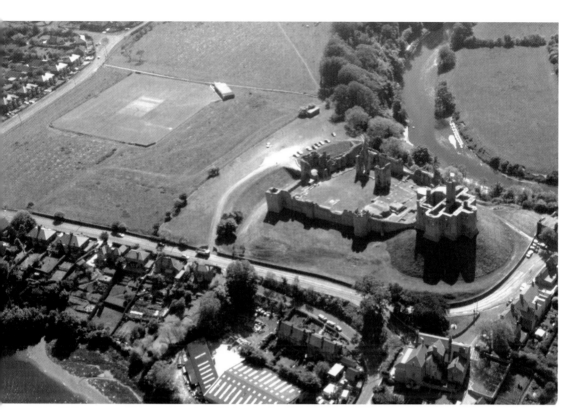

6. The castle from the east.

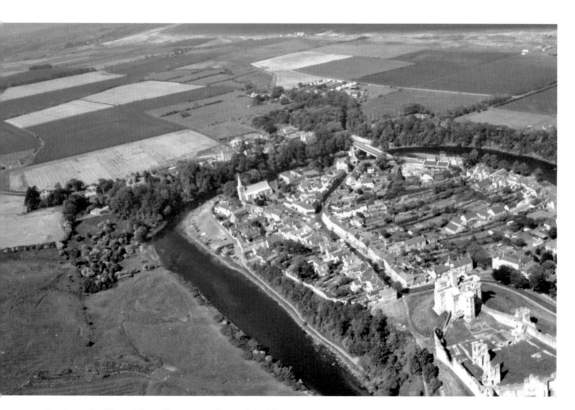

7. Castle and village. The village was planned and burgage strips gave each cottage an allotment. The Norman church lies at the south end, and the river is crossed there by a defended medieval bridge and a modern one.

8. A view from the port of Amble northwards to the castle.

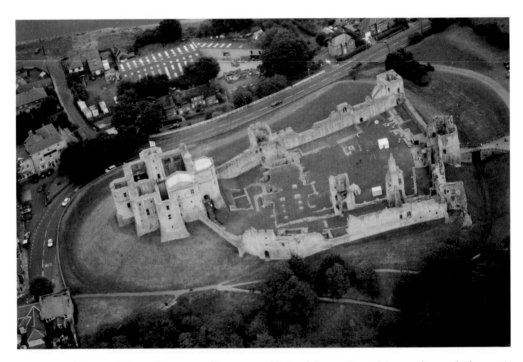

9. A view of the castle from the air sees the motte, with its elaborate keep, lying to the north (bottom), from which the curtain walls widen out to the south wall and moat. To the left, the Grey Mare's Tail Tower lies on the east curtain wall, where there is a stable block marked by its foundations, linked to the Montagu Tower at the south-east corner.

The gateway is central to the south wall, with a range of buildings to the right that includes a chapel and solar. To the west (right) another range includes the Hall, kitchens and buttery, accessed by the Lion Tower and the Little Stair Tower. Dividing the interior from east to west are the foundations of a church and crypt, with the Postern Tower to the west. (*Gordon Tinsley*)

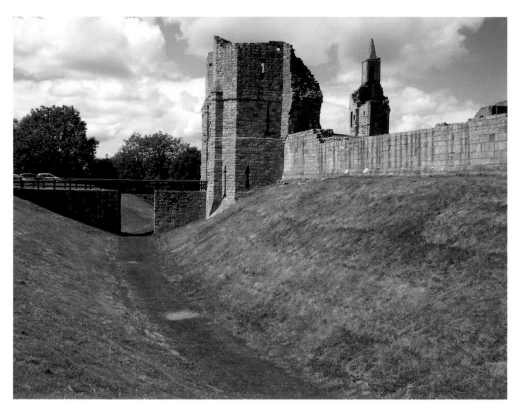

10. The moat to the south cuts off the peninsula; here we look west to the gatehouse.

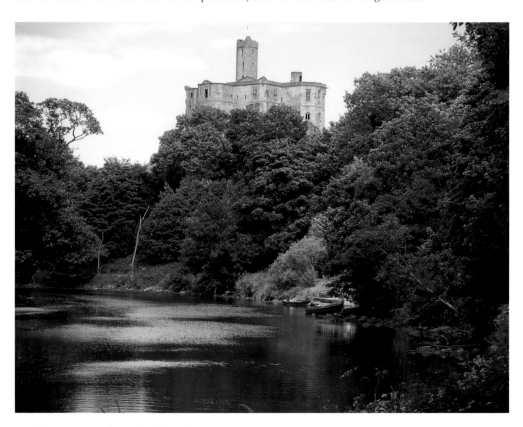

11. The keep rises above the River Coquet.

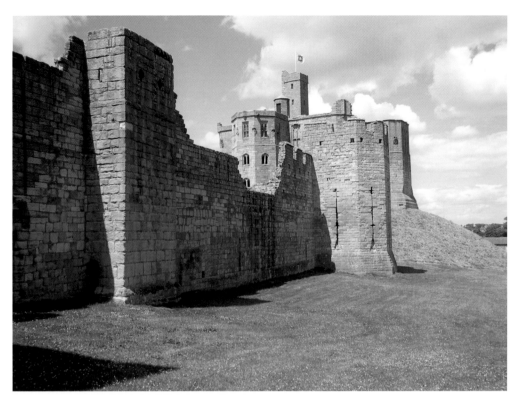

12. The east wall, pulled in from its original line, with the keep at the top, and the Grey Mare's Tail Tower nearest the camera.

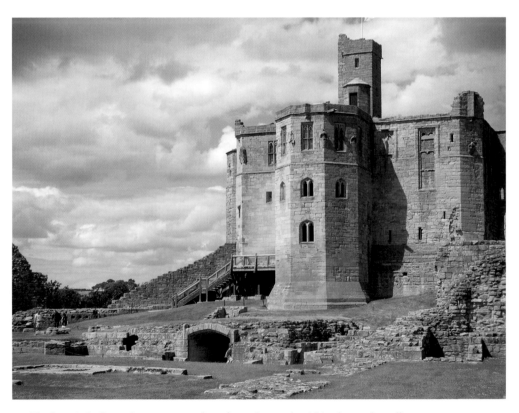

13. The keep is built on the motte, seen here from the south within the castle wall.

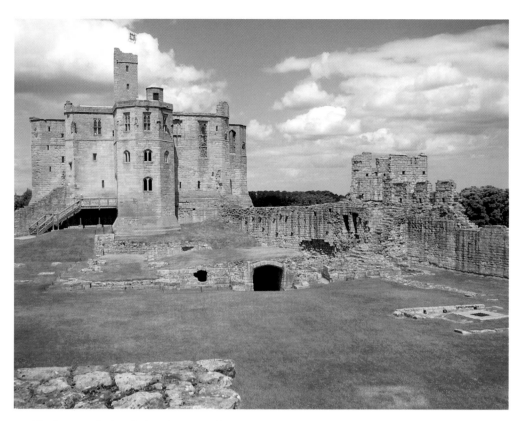

14. The keep, with church foundations in front and east wall to the right.

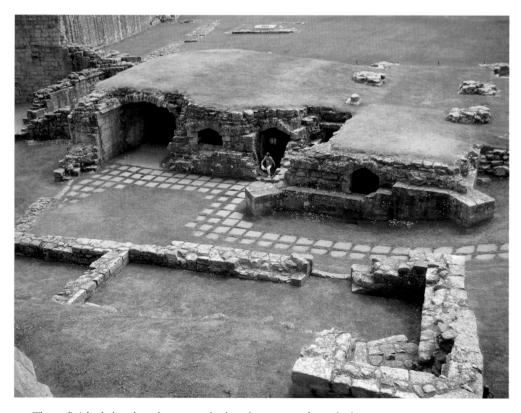

15. The unfinished church and crypt, and a brewhouse, seen from the keep.

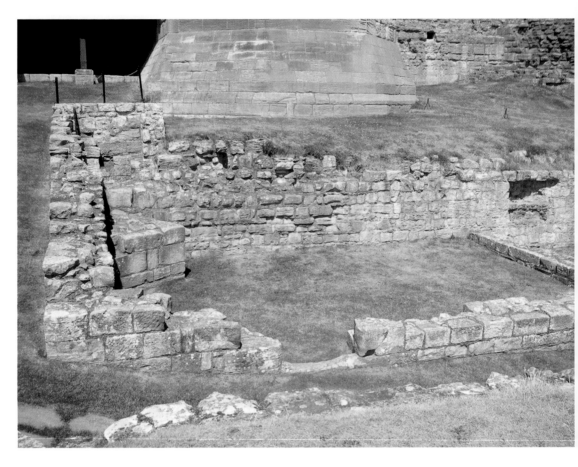

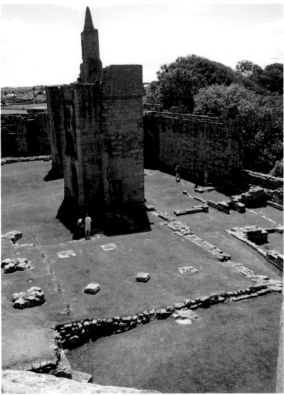

Above: 16. A closer look at the brewhouse – beer was essential when much of the water was contaminated, and more pleasant to drink.

Left: 17. A view from the keep to the hall buildings, southwards.

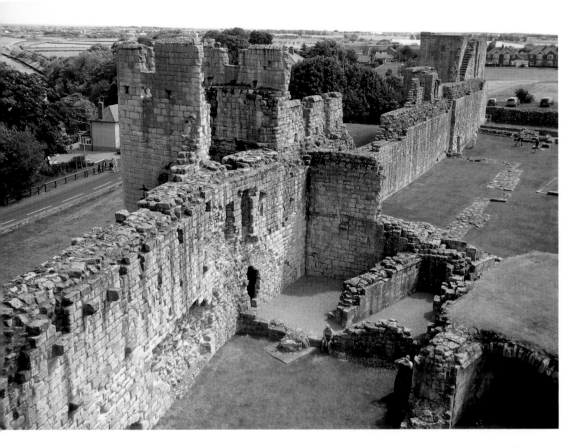

Above: 18. From the same viewpoint, we see the east wall, and Grey Mare's Tail Tower and stable block.

Right: 19. To the far south is the wall of the solar, where the well-windowed family rooms looked out over the sunny side of the castle.

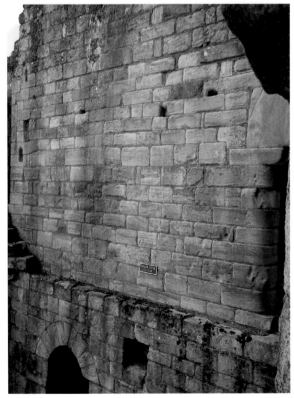

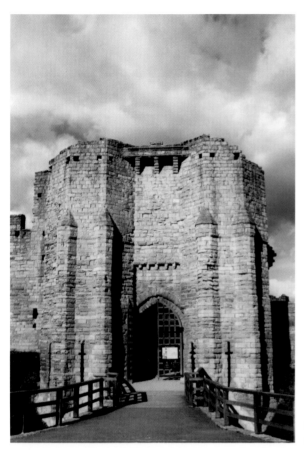

20. The gatehouse controls access by drawbridge over the moat.

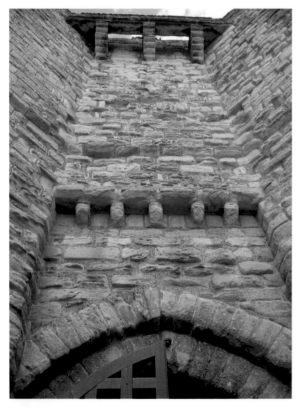

21. Detail of the gatehouse arch; above the entrance are slots that played a part in the defence of the gateway.

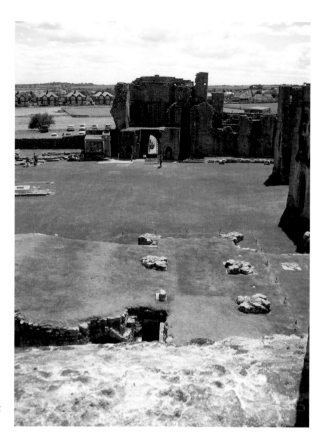

Right: 22. A view of the back of the gatehouse and south range, from the keep.

Below: 23. At the back of the gatehouse, reached by two sets of spiral stairs, is the slot for the portcullis, seen here.

24. To the right (west) of the gate is the chapel and solar block.

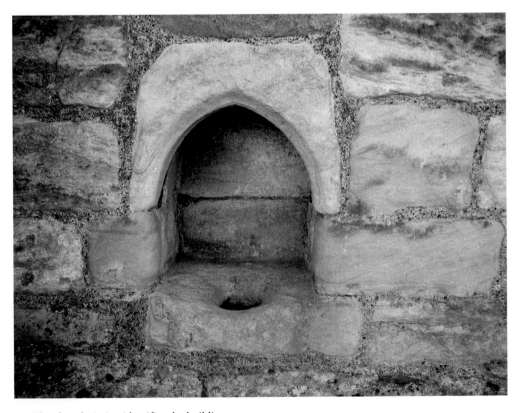

25. The chapel piscina identifies the building.

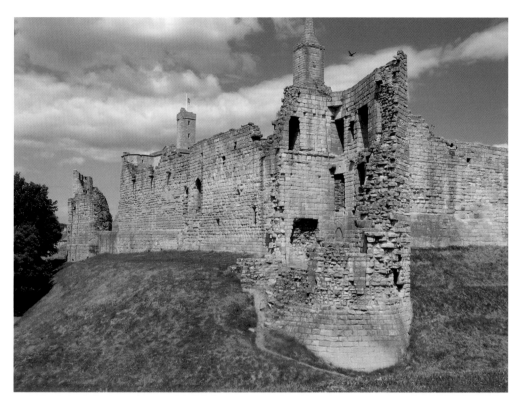

26. At the south-west corner the Carrickfergus Tower projects into the moat, and here the main living accommodation of the owners was built.

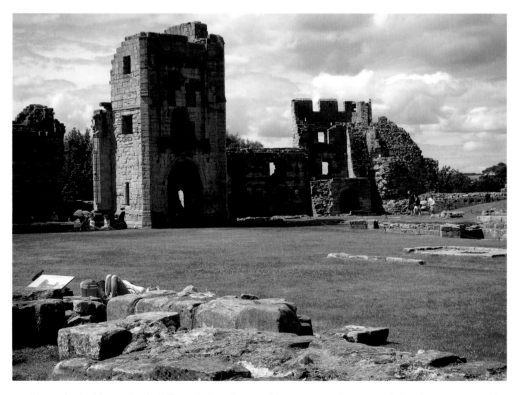

27. From the inside, again, buildings designed for residence, entertainment and feasting are entered by the Little Stair Tower and Lion Tower, the latter displaying the family coats of arms.

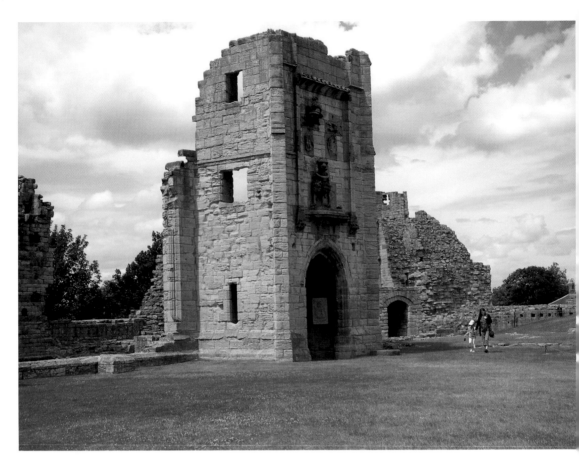

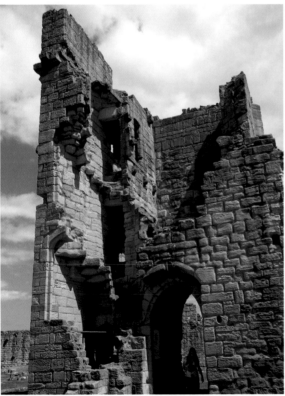

Above: 28. The south-east corner of the Lion Tower.

Left: 29. A cross-section of the Lion Tower from the inside, showing its structure and use.

Above: 30. The entrance to the Lion Tower has elaborate vaulting, making the entrance even more impressive.

Right: 31. The family arms of the Percys are well-displayed: the Percy lion with the war-cry 'Esperaunce'(Hope) above the door; the arms abandoned in 1343 left above that; the three pike ('Luces', making a pun on a Lucy branch of the family), top right; and a narrow band above with family badges.

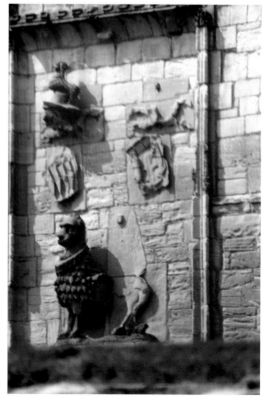

32. Fan vaulting is the basis for the decoration just above the arch, reminiscent of the nave screen at York Minster.

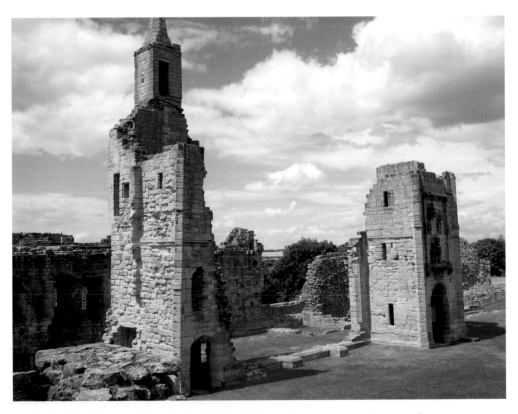

33. To the left of the Lion Tower is the Little Stair Tower; the two are seen here together.

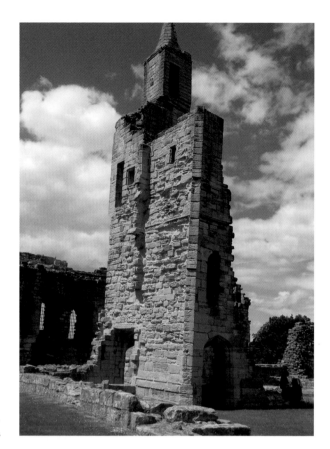

34. The Little Stair Tower, with a spire, leads into the duke's private chamber via an anteroom; it was partly rebuilt in the 1920s.

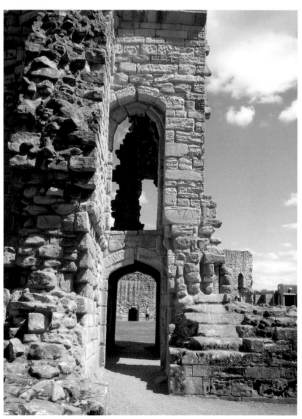

35. Inside the tower, looking east.

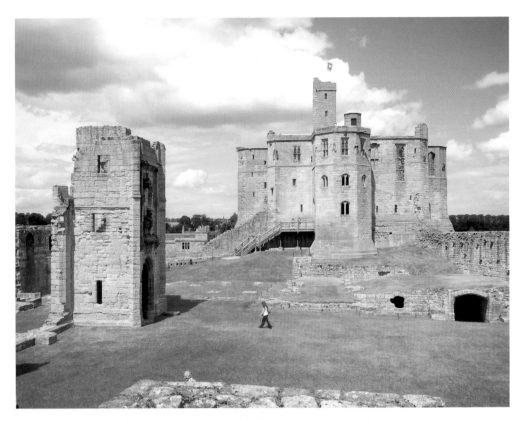

36. A view of the Lion Tower with the keep and collegiate church beyond.

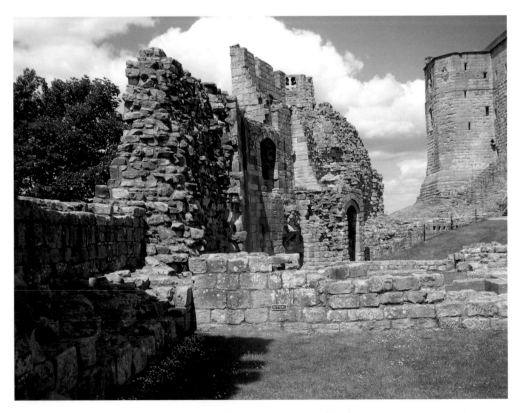

37. To the west, built against the curtain wall, are the buttery and kitchen.

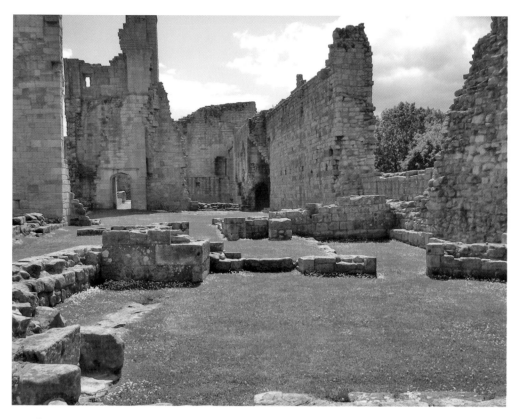

38. The Great Hall was the focus of entertainment and feasts.

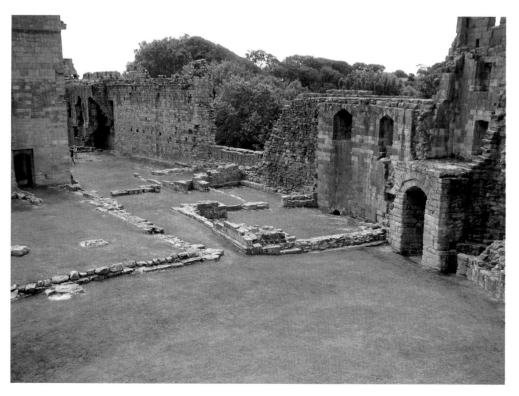

39. A church continues from these buildings to the east to Grey Mare's Tower, forming a definite boundary between the Outer and Inner Ward.

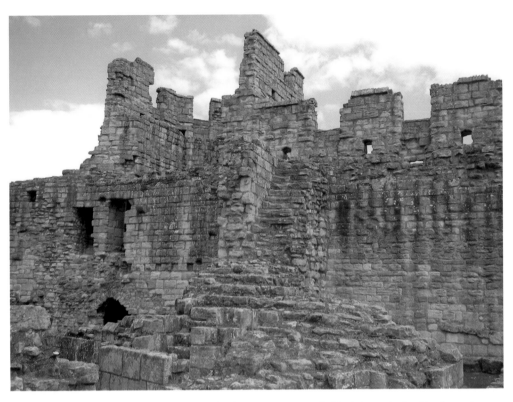

40. The polygonal Grey Mare's Tail Tower, built in 1290, is seen behind the stairs leading from the east end of the church.

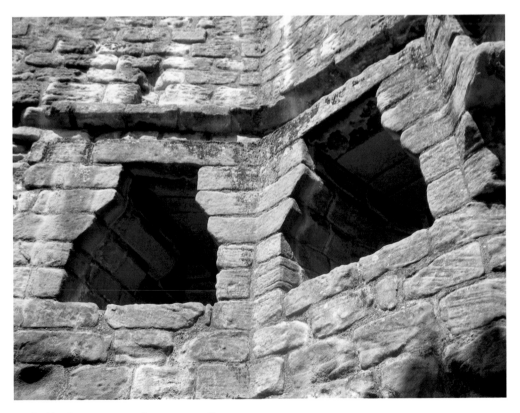

41. Inside, there are arrow-loops on two floors.

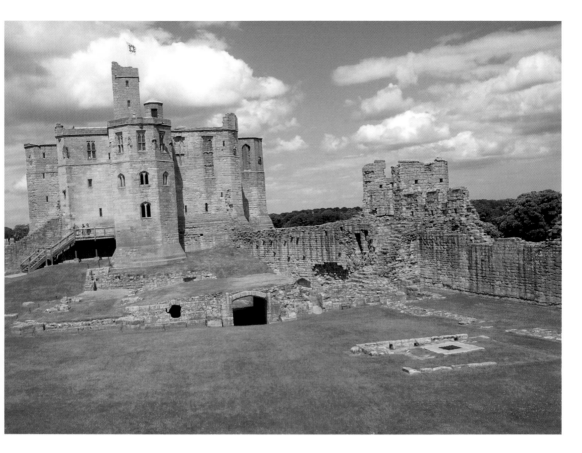

Above: 42. We look back again to see the keep and Tower.

Right: 43. The east wall continues south where the walls of the Outer Ward are used for stables and other buildings, with the Montagu Tower at the south-east corner.

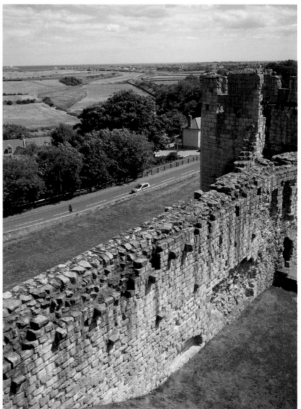

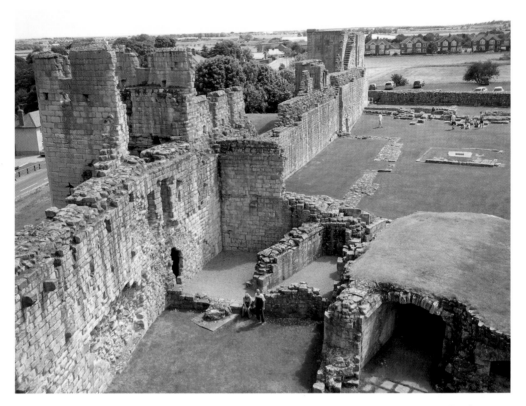

44. These buildings formed an essential part of life in the castle, providing accommodation for the many people necessary to the running of the castle and its defence.

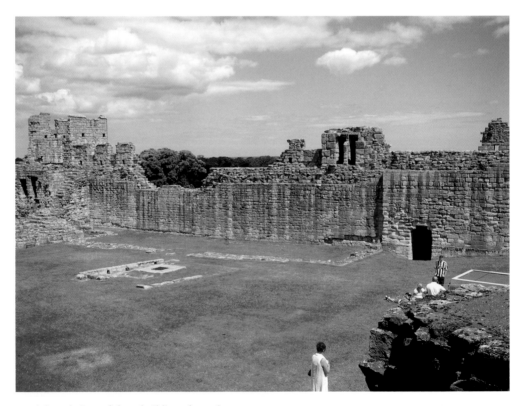

45. A broad view of these buildings from the west.

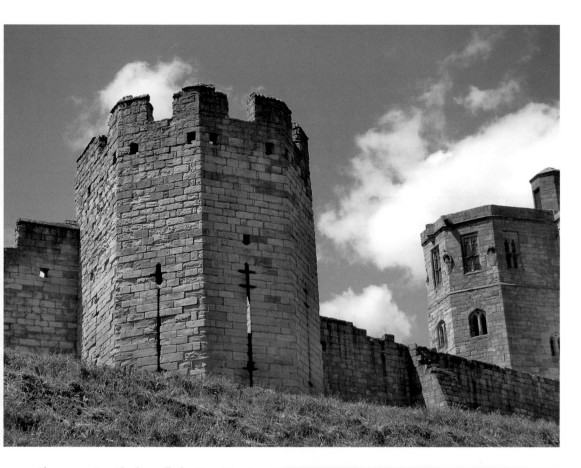

Above: 46. Outside the wall, the Grey Mare's Tail Tower protrudes, with the keep beyond.

Right: 47. The south-east corner tower, the Montagu Tower, erected in the 1460s.

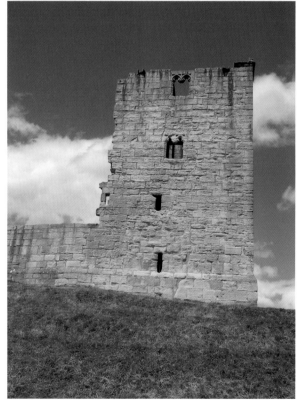

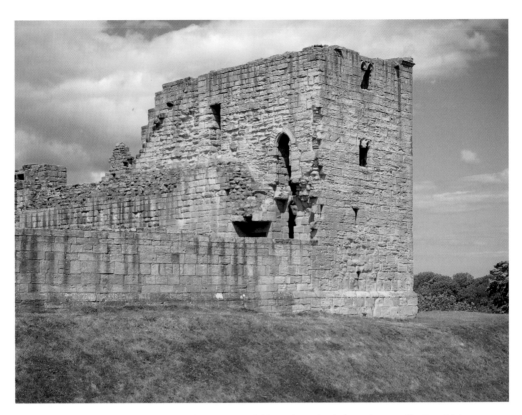

48. Seen from inside the castle wall, the tower could have been built by John Neville, Lord Montagu.

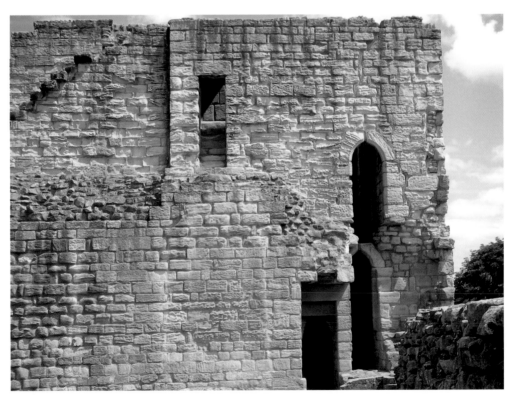

49. A further detail shows the entrance, which leads to upper rooms with latrines and fireplaces, so it was probably intended for important members of the household.

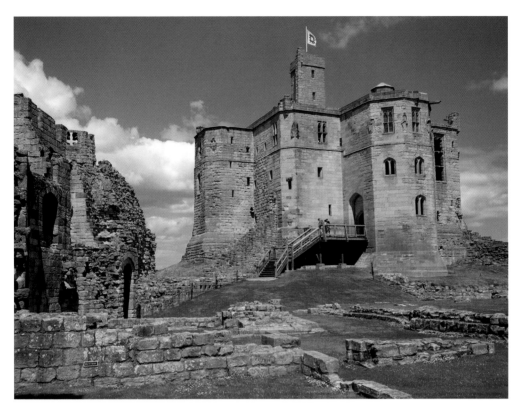

50. We cross the ward again to the kitchen range, with the keep beyond.

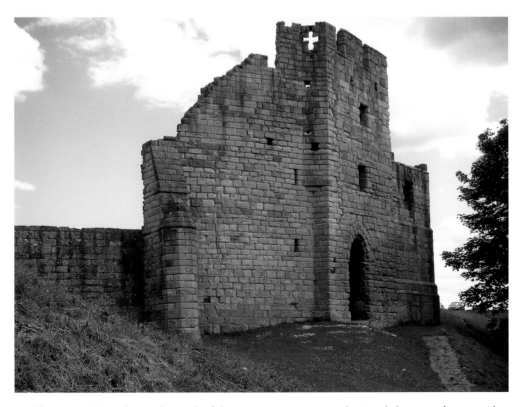

51. The Postern Tower lies to the north of this range, opening out to the river below, seen from outside.

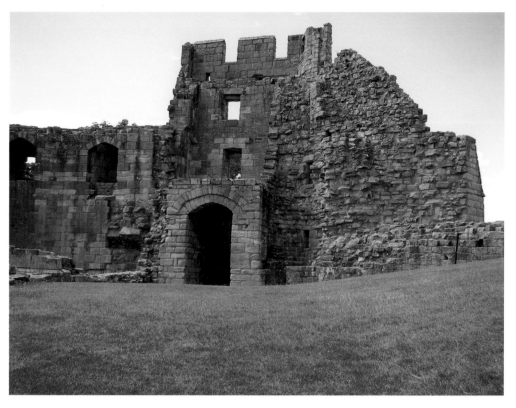

52. A view of the opening from the east.

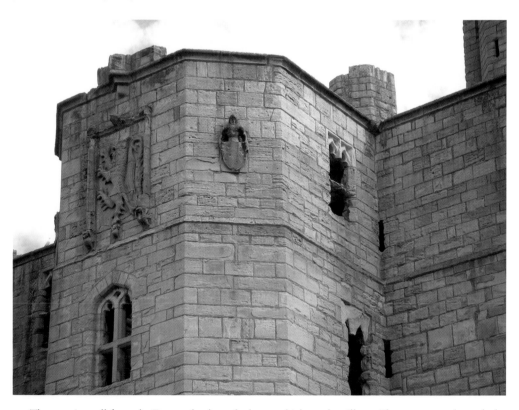

53. The curtain wall from the Postern leads to the keep, which on the village side announces through the lion that its owners are the Percy family.

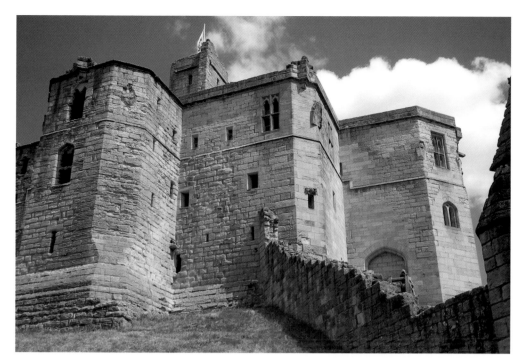

54. The keep, seen from the west, is one of the finest features of any northern castle, its rebuilding being of the late fourteenth century and early fifteenth century, with further building and alteration in the sixteenth century, all of which have eliminated traces of the Norman keep. Carved on the outside are owners' shields.

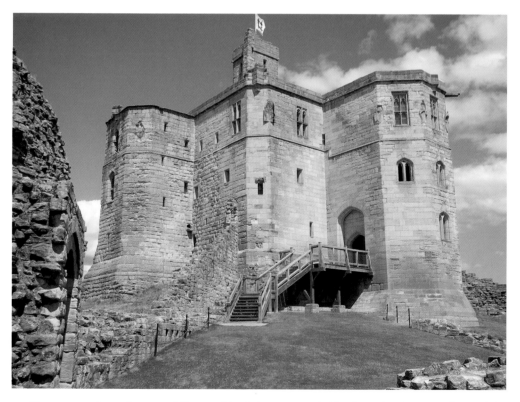

55. The entrance is on the ground floor and leads into a remarkable piece of architecture designed for quality living.

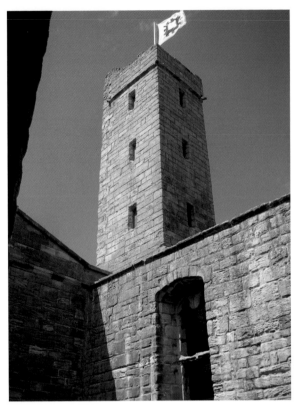

Left: 56. The keep is a formal design focused on a 'lantern' or 'light' at its centre – space that lets in light to the many rooms on all floors and collects water in cisterns to flush the toilets.

Below: 57. Seen here from the east, the keep is a square with bevelled corners. The turrets are polygonal. There are three storeys with guard rooms, cellars, pantry, buttery, kitchen, chapel, hall, solar and other rooms; this is a compact and luxurious (for the time) space that displays all the trappings of power, made possible by the ingenuity of its architects. It is duplicated by the functions that we have seen in the Outer Ward.

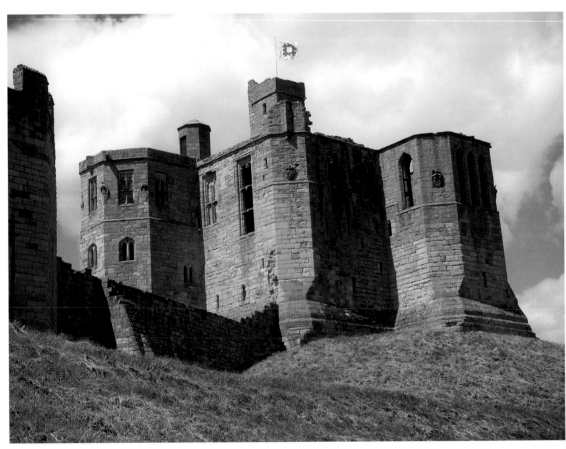

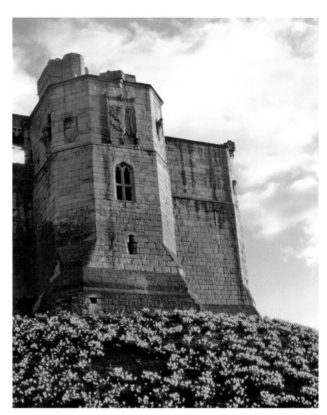

Right: 58. From the west again, we see the site in spring.

Below: 59. Inside the Great Hall, this is the west wall.

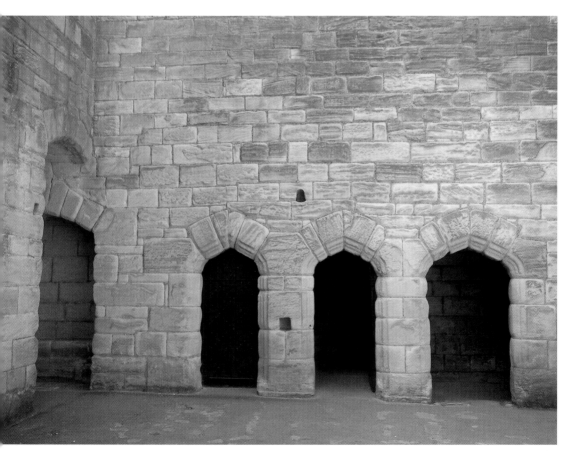

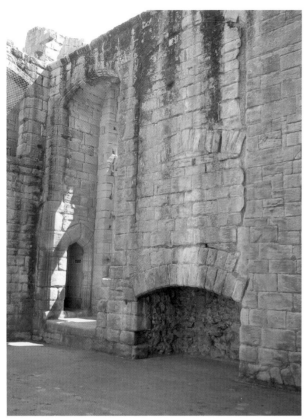

Left: 60. The Great Hall: a window opening, later blocked as a fireplace.

Below: 61. Elaborate windows and a wall passage in the Great Hall.

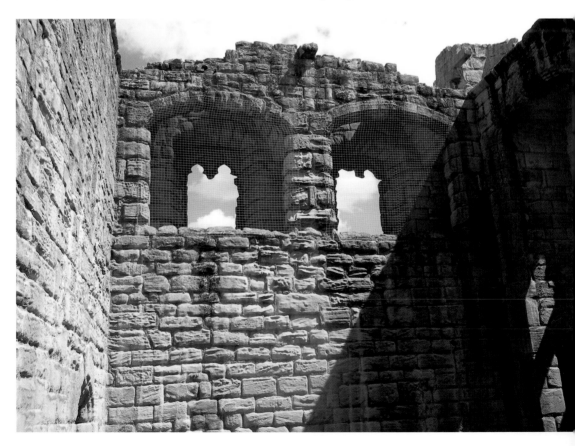

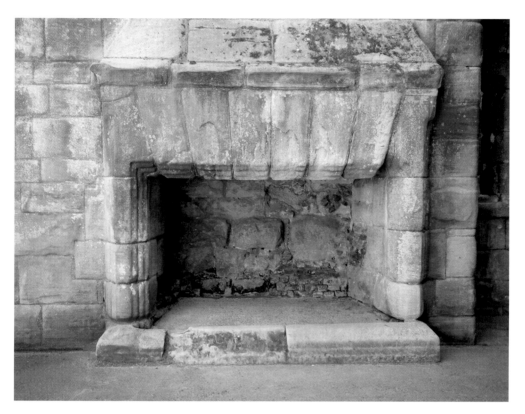

62. One of the smaller fireplaces in the keep.

63. A huge kitchen fireplace for preparing huge meals in the Hall.

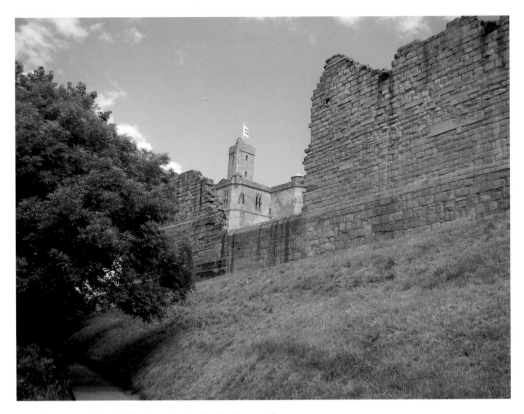

64. The west wall with the keep in the far background.

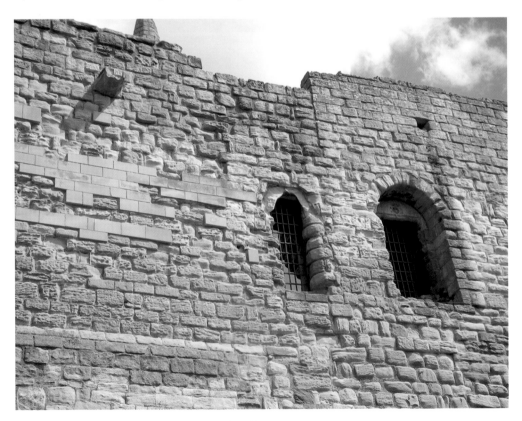

65. Detail of the west wall and its changes. The oldest part is Norman.

66. The village of Warkworth was planned, with buildings and their garden plots running from the main street, which led to the church and the bridge. Here is the gateway guarding the bridge, looking north.

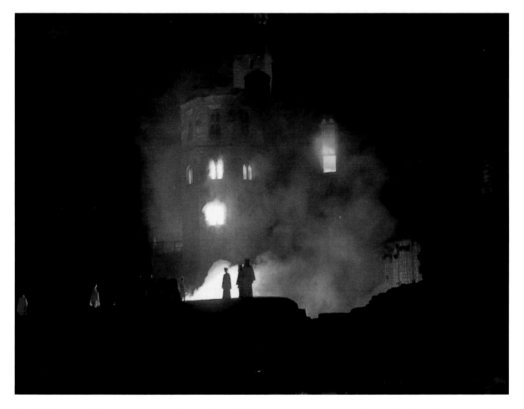

67. Today the village is not a fossilised piece of history, as the three-yearly production of a pageant has proved. The finale was the siege of the castle by the forces of Henry IV, with the help of the RAF in a pyrotechnic display!

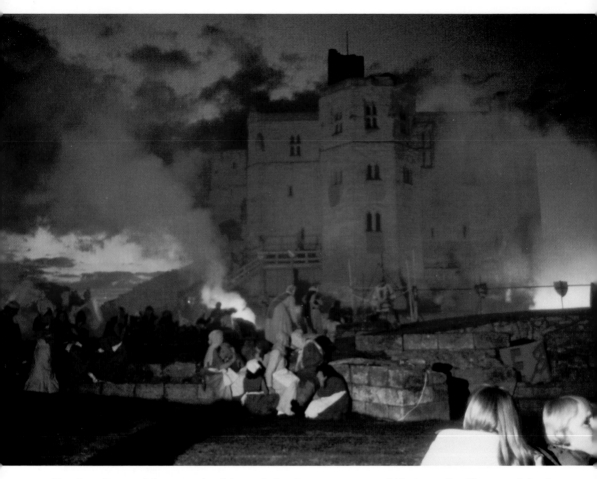

68. Here is a glimpse of the use made of the castle for the 1977 pageant which shows the villagers and the site itself in a different, exciting light. I was fortunate to be involved in the production, when the pre-war pageant was revived.